DRAW LIKE AN ARTIST

100
BUILDINGS &
ARCHITECTURAL
FORMS

Step-by-Step Realistic Line Drawing

A Sourcebook for Aspiring Artists and Designers

DAVID DRAZIL

Inspiring | Educating | Creating | Entertaining

Brimming with creative inspiration, how-to projects, and useful information to enrich your everyday life, Quarto Knows is a favorite destination for those pursuing their interests and passions. Visit our site and dig deeper with our books into your area of interest: Quarto Creates, Quarto Cooks, Quarto Homes, Quarto Lives, Quarto Drives, Quarto Explores, Quarto Gifts, or Quarto Kids.

Digital edition published in 2021
eISBN: 978-0-7603-7077-3

Design: Quarto Publishing Group USA Inc.
Illustration: David Drazil

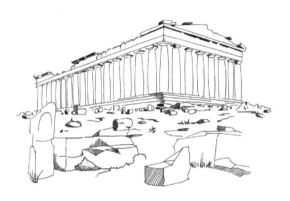

To all of you who seek progress in your creative endeavors.
To all of the fans of sketching and architecture, creatives,
and life-long learners. Have fun and happy sketching!

CONTENTS

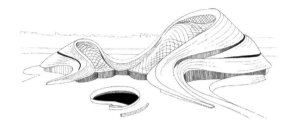

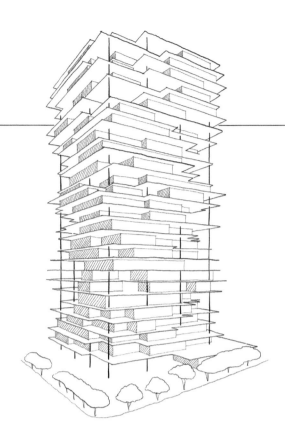

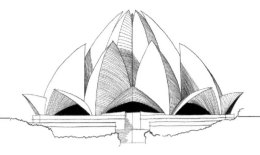

HISTORIC / SACRED / MONUMENTS

CULTURAL
(MUSEUMS / GALLERIES / LIBRARIES)

BRIDGES

TOWERS / HIGH-RISES / SKYSCRAPERS

SPORTS FACILITIES

LANDSCAPE ARCHITECTURE

INTRODUCTION

Even in the twenty-first century, free-hand sketching and drawing play important roles in both designing and visualizing architectural projects and ideas.

As architects, we use hand-drawing as one of the tools in our toolkit. Through drawing, we brainstorm and develop ideas. We shape these ideas, and through an iterative process, we give them form. Sketching and drawing help us to understand problems, solve them, and communicate the solutions to others.

Hand-drawing has one huge advantage over any computer program—it is based on our natural and instant connection between our mind and hands. The hand-drawing process is unobstructed by any technological barrier and allows us to get into the state of flow, where our creativity and problem-solving skills are at their peak.

This book will help you not only to adopt an effective approach to the architectural sketching process but also to understand the depicted buildings better—their proportions, scale, structure, and tectonics.

Since drawing is simultaneously seeing, thinking, and understanding, I hope this book will help you discover a new angle of how you can look at architecture surrounding us.

HOW TO USE THIS BOOK

This book depicts a variety of architectural buildings and structures from all around the world, shown in a step-by-step drawing process. It should serve you as inspiration and as a visual reference you can follow to achieve the same results.

Feel free to skip around and draw the buildings that you like or that you find challenging to draw. Even though the process depicted on these pages suggests one approach, don't feel limited by it. Use it as a guideline for your own drawing process and don't hesitate to go your own way or add extra layers of shading and coloring if it fits your style and intention.

Suggested Materials

Every image you see in this book was drawn free-hand without any rulers, protractors, or similar tools. Whether you prefer to draw in a traditional way or digitally, here are recommended tools you can use:

 If working traditionally:
 - Graphite pencil
 - Fine-liner pens with different line weights (choose two to three thicknesses anywhere from 0.05 mm to 1 mm)
 - Any paper that you enjoy working on; plain office paper 80g/m² will do just fine
 - Eraser

 If working digitally:
 - Photoshop and a graphic tablet
 - iPad with Apple pencil and Procreate, Morpholio Trace, or any other preferred drawing app

Start with Composition

The drawing process starts with outlining the structure of the overall composition, including the most important vertical and horizontal lines/edges. Very often it involves setting up a perspective grid with the horizon line and vanishing points. In this phase, use a pencil to draw very lightly, as these construction guidelines are mostly to serve the process and they eventually can be erased.

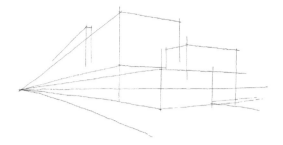

STEP 1

Outline Volumes & Context

Next, use the established composition structure and define the main volumes, adding their closest surroundings to provide context. This might include drawing the elements in the foreground, such as vegetation and trees. Blocking out the foreground makes it easier, as we won't need to draw the areas behind these elements.

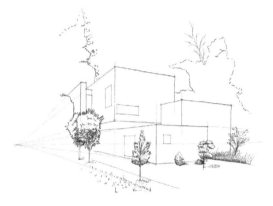

STEP 2

Add Textures

To express materiality in drawings, add textures suggesting different real-life materials commonly used in architecture, such as timber, stone, concrete, steel, and glass. These textures work as graphic shortcuts—simplified versions of reality—and add a new layer of information and detail to drawings. The more detail we add, the more the viewer's attention is drawn to a certain area of an image. That's why it makes sense to use selective texturing—applying textures to highlight only the parts of an image on which we want a viewer to focus.

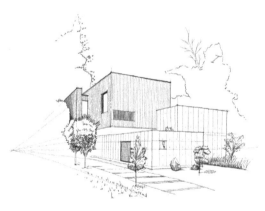

STEP 3

Shading & Final Touches

Finally, to increase contrast and a sense of plasticity, add shading. Shading can be observed from a reference or it can be deliberately decided by an artist. Either way, it's a good idea to define the light source and the main direction of light so we know which surfaces should be lit (exposed to light) and which should be shaded (light is blocked by other surfaces).

As for final touches, you may want to erase the original construction guidelines drawn in pencil during the first step and clean up anything unwanted. Optionally, you can add more contextual information by drawing sky or water reflections (as used in other examples in this book).

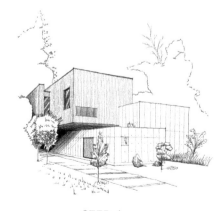

STEP 4

TIPS ON ARCHITECTURAL SKETCHING & DRAWING

TIP #1: LEARN TO DRAW LONG, STRAIGHT LINES

All the architectural drawings in this book are based on lines. The lines are used not only for contours, but also for guidelines, constructional lines, shading, hatching, and texturing—pretty much everything in a drawing. You'll find out that most of these lines are simply straight and are sometimes very long. That's why it's a great idea to practice drawing confident long, straight lines.

EXERCISE: Grab a blank sheet of paper and fill it with three layers of lines—vertical lines, horizontal lines, and diagonal lines. Treat this as a warm-up exercise before drawing, just as you would warm up before any sport activity.

To achieve confidence in long straight lines, I suggest the following: First, draw with your whole your arm, starting the movement from your shoulder, and avoid bending your wrist. Second, look and focus on the endpoint of a line you're drawing. This will help to naturally guide your hand to where you're looking.

TIP #2: VARY THE LINE WEIGHT

Use of different line weights—thicknesses of pen strokes—serves well for defining depth planes, for better clarity, and for creating emphasis and contrast in a drawing.

To use different line weights to support the illusion of depth, use thicker strokes in the foreground—depicting elements close to the viewer—and thinner lines in the background, such as trees, mountains, or a cityscape in the distance.

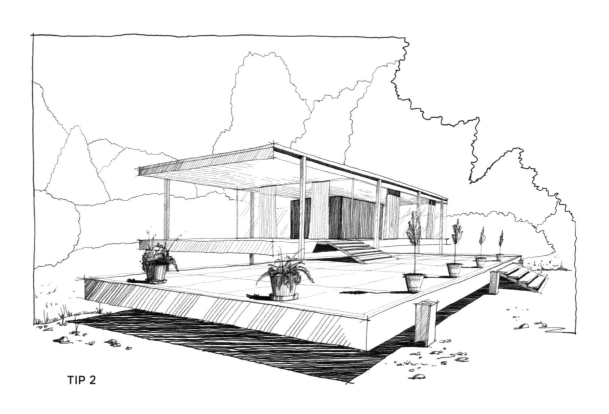

TIP 2

TIP #3: START WITH IMAGINARY BOUNDING BOXES

Before diving into details, set your main volumes in perspective by drawing imaginary bounding boxes surrounding the main volumes. These simple boxes help ensure that your perspective view is correct and prepares you to draw more defined volumes and details inside.

TIP #4: USE CROSS-HATCHING FOR SHADING

Hatching is commonly used to add textures or shading. Cross-hatching is the same, just applied in two or more layers on top of each other. Each new layer should have a different direction from the previous one. In that way, you can achieve very gradual darkening of big areas, which can create illusions of soft shading.

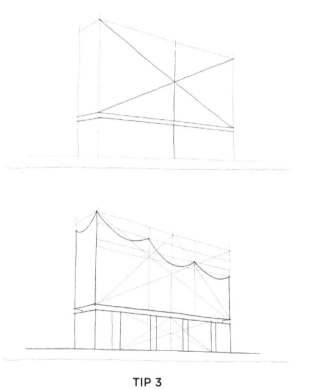

TIP 3

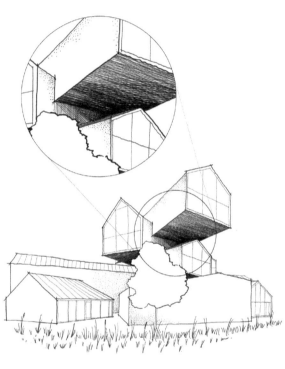

TIP 4

TIP #5: TRAIN YOUR OBSERVATION SKILLS

If I were to choose just one thing that is often neglected but has dramatic impact on sketches, it would be observation skills. Learn to observe and understand why things work and look like they do. Observation skills are essential for good sketching, composition, light and shadows, proportions, materiality, and everything else. Train yourself to become better at observing positive and negative space of objects, their proportions, and spatial relations between them. It's a skill like any other and, with a little bit of practice, you'll get better at it and, more importantly, your sketches will improve. Sketching and drawing forces you to understand the object first before drawing it. In that way, when you sketch, you're always learning something new.

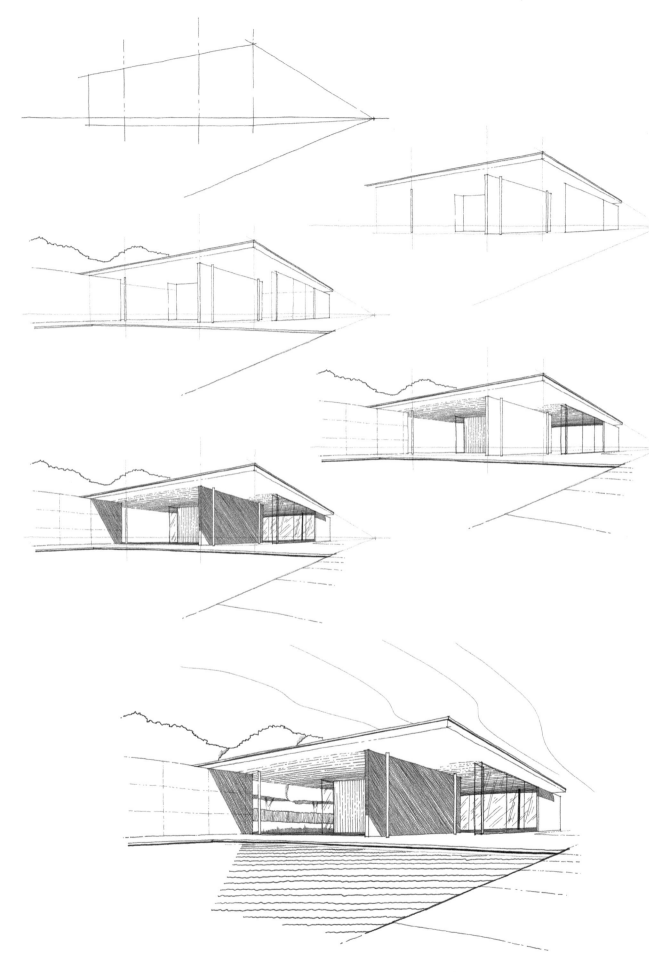

THE GERMAN PAVILION / LUDWIG MIES VAN DER ROHE | BARCELONA, SPAIN

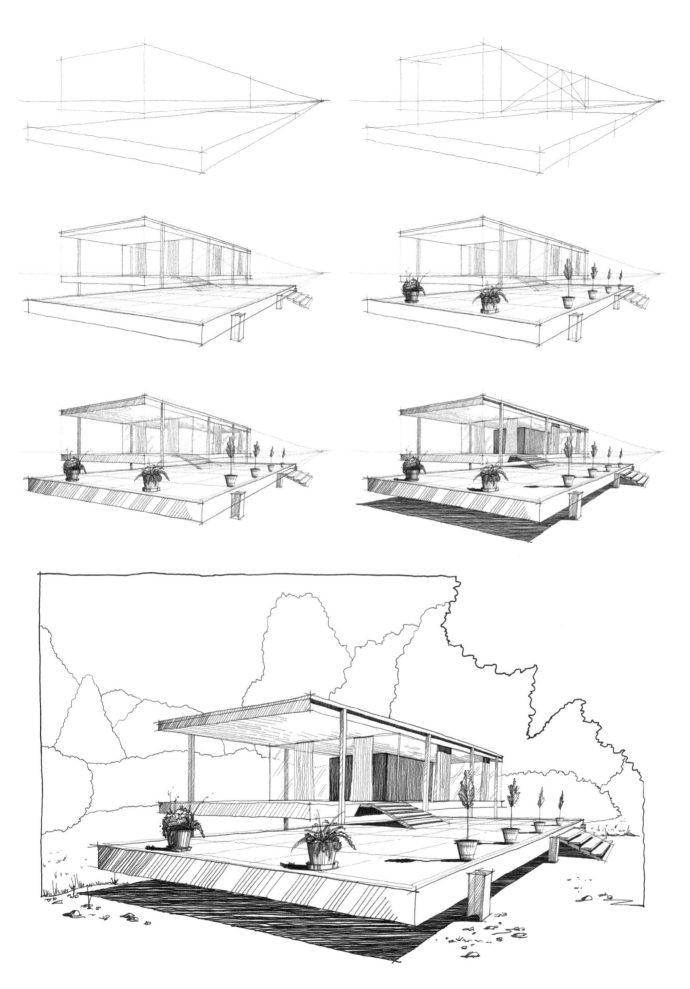

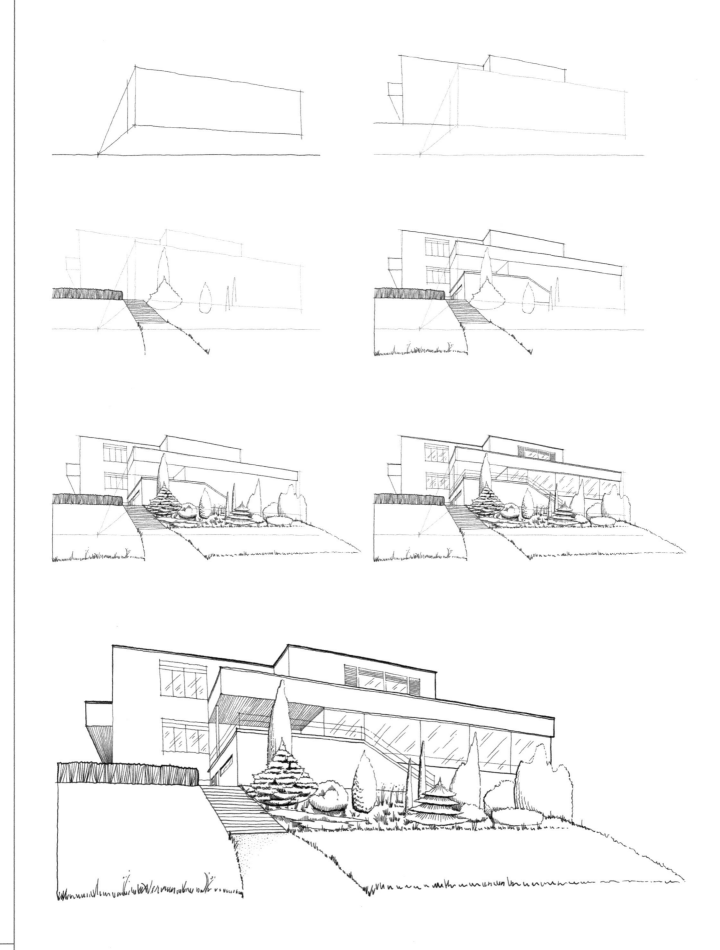

VILLA TUGENDHAT / LUDWIG MIES VAN DER ROHE | BRNO, CZECH REPUBLIC

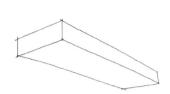
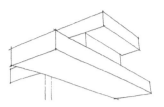
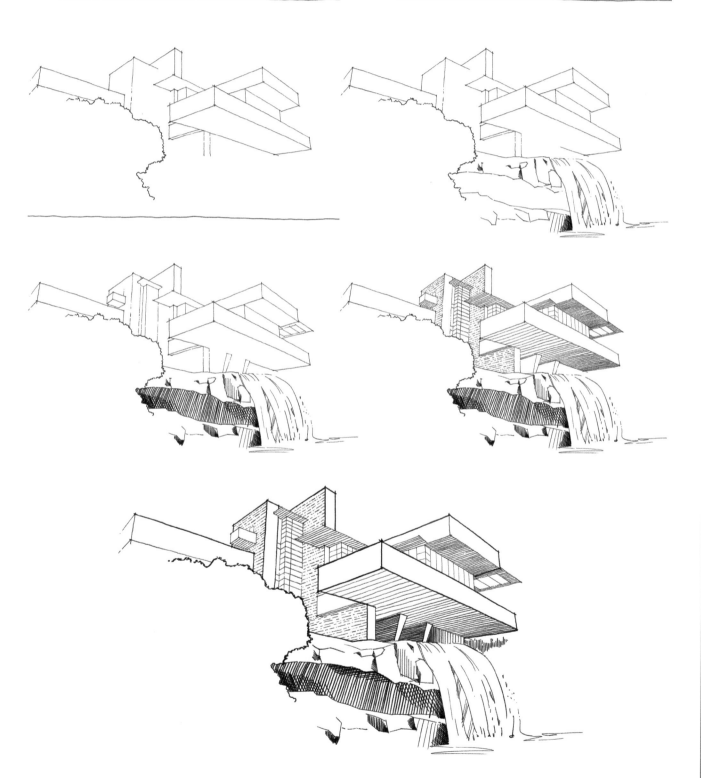

FALLINGWATER / FRANK LLOYD WRIGHT | MILL RUN, PENNSYLVANIA, USA

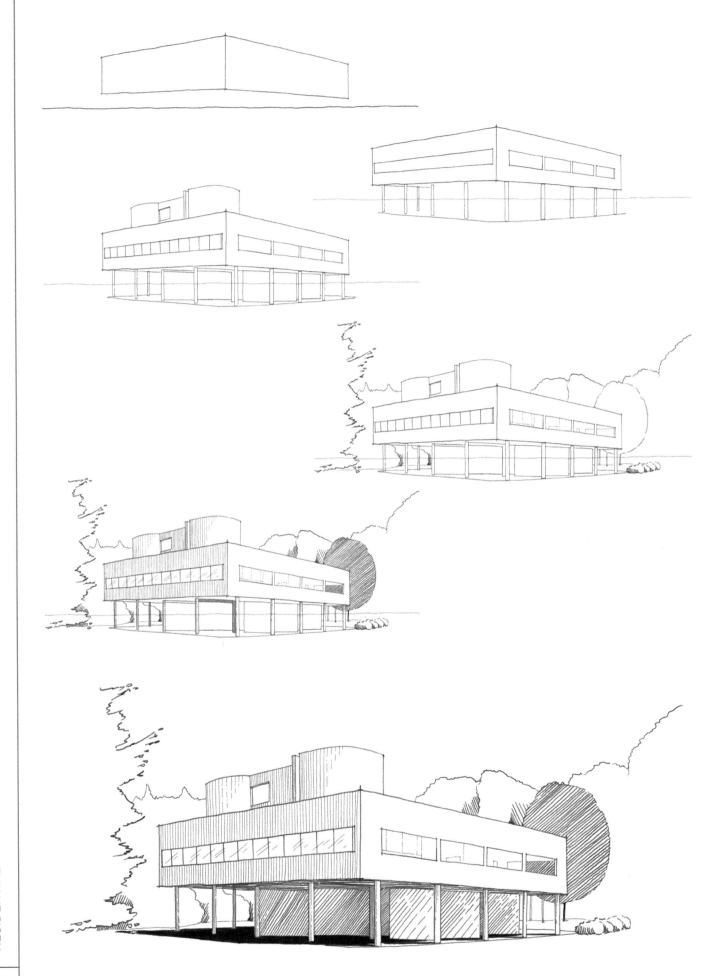

VILLA SAVOYE / LE CORBUSIER | POISSY, FRANCE

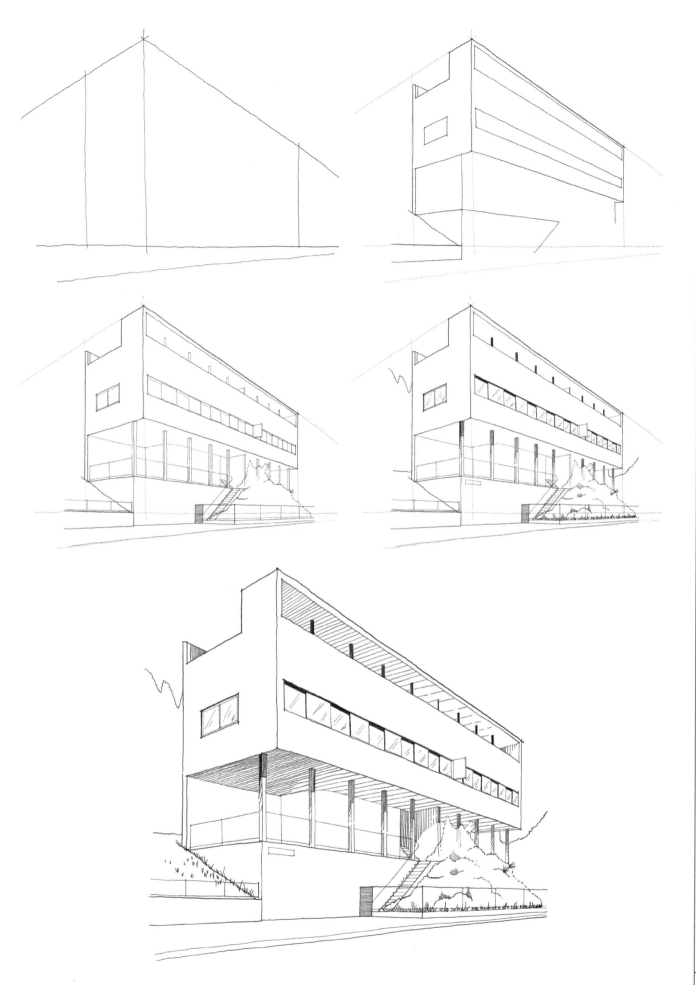

WEISSENHOF ESTATE / LE CORBUSIER | STUTTGART, GERMANY

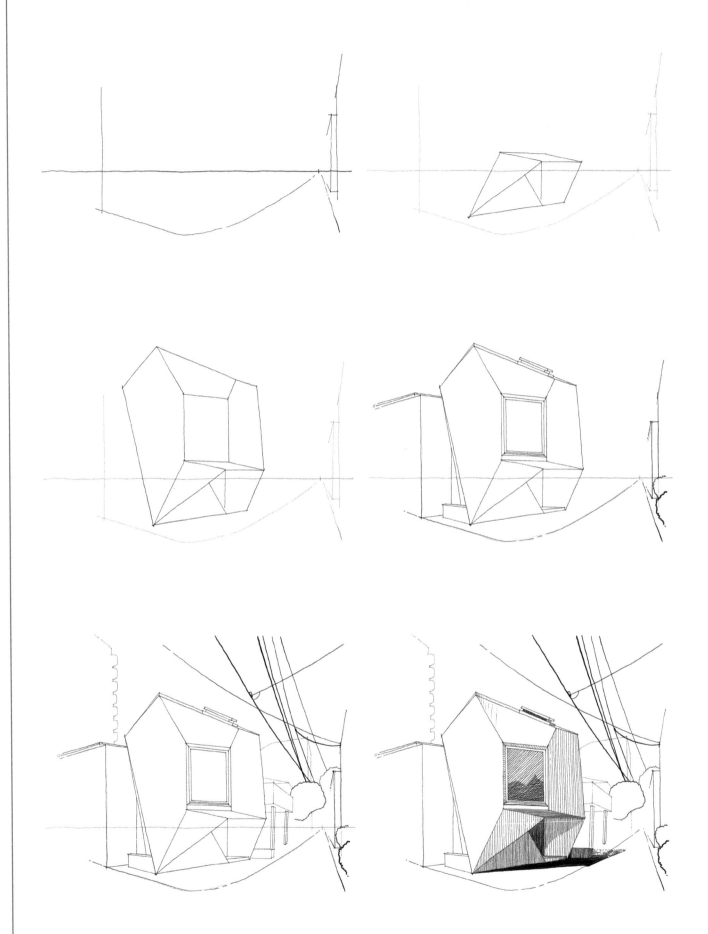

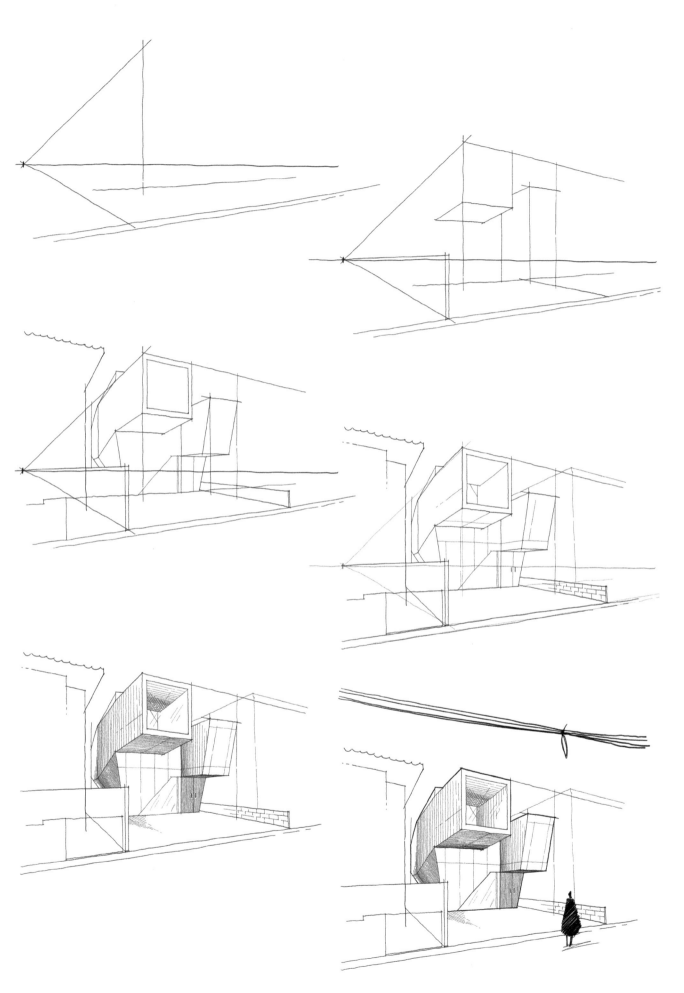

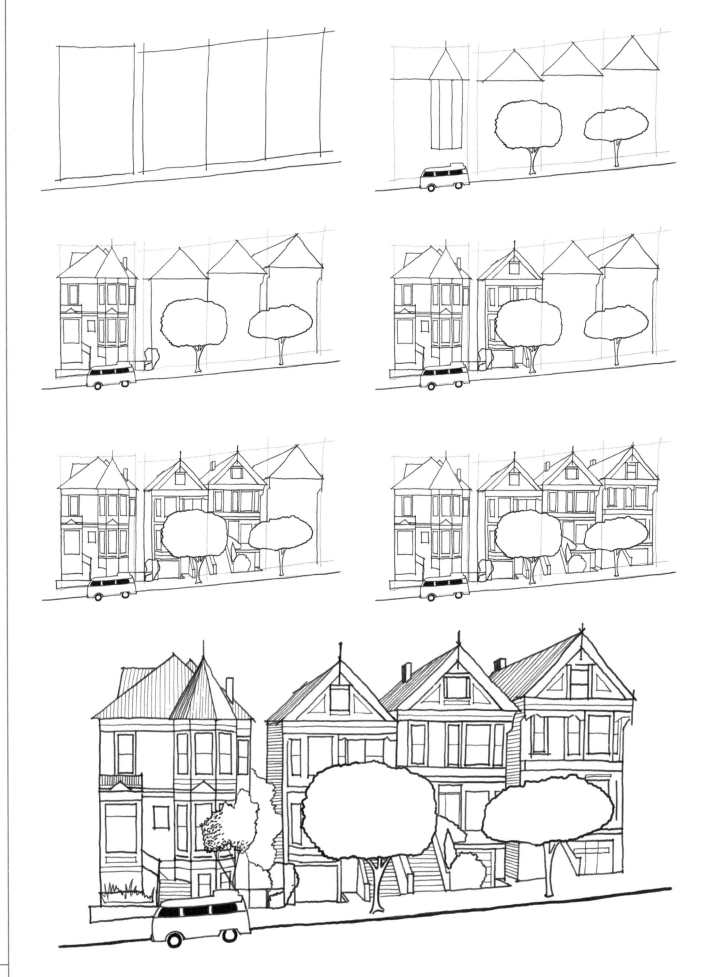

VICTORIAN PAINTED LADIES | SAN FRANCISCO, CALIFORNIA, USA

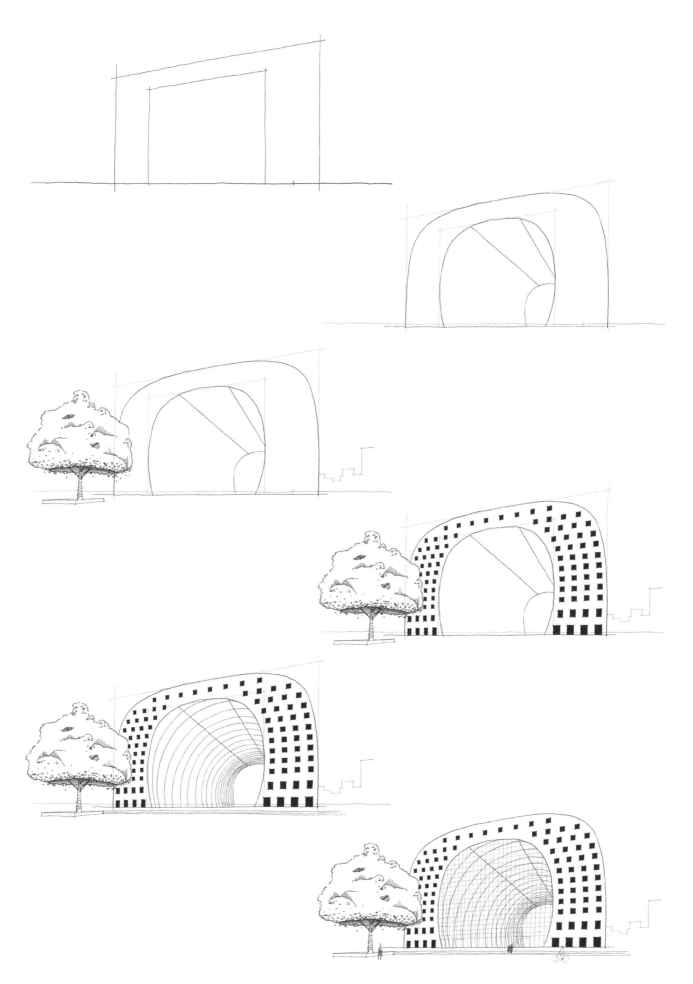

MARKTHAL / MVRDV | ROTTERDAM, NETHERLANDS

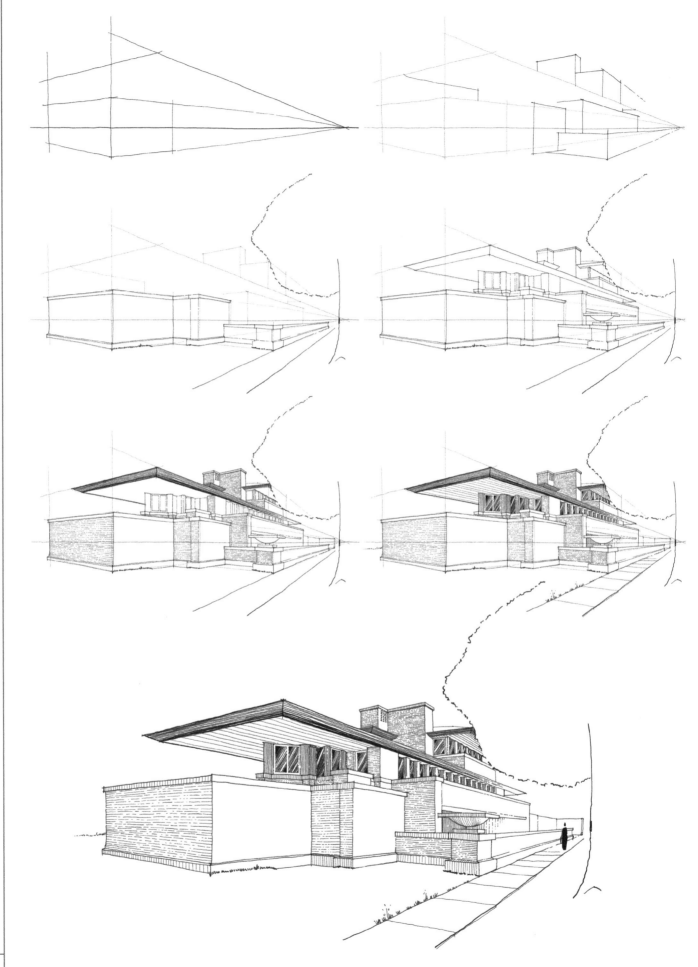

ROBIE HOUSE / FRANK LLOYD WRIGHT | CHICAGO, ILLINOIS, USA

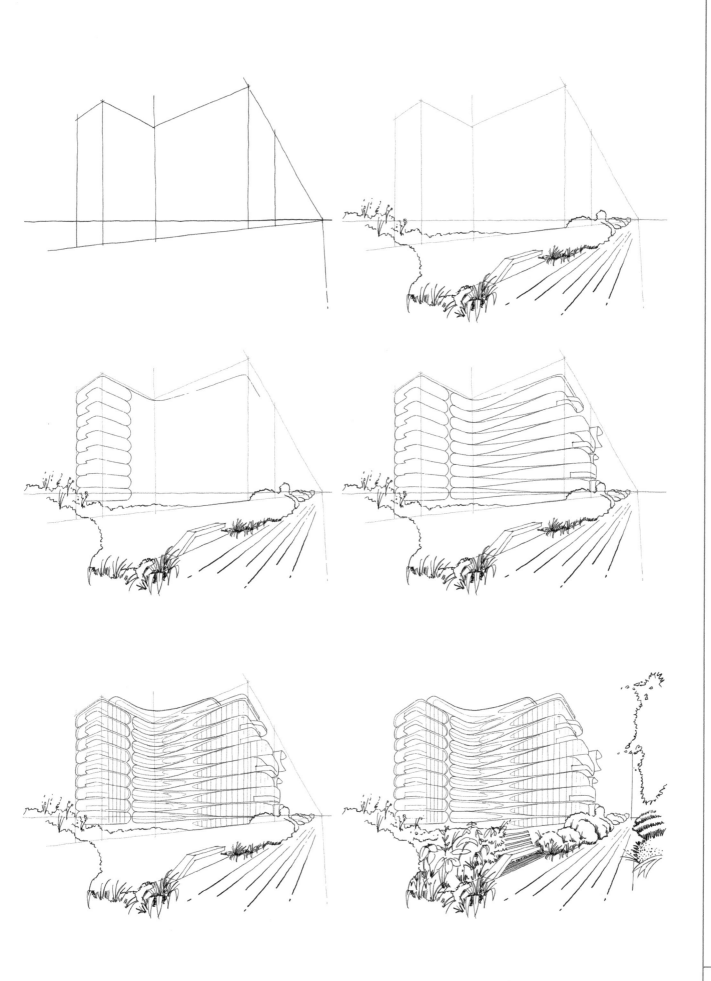

RESIDENTIAL

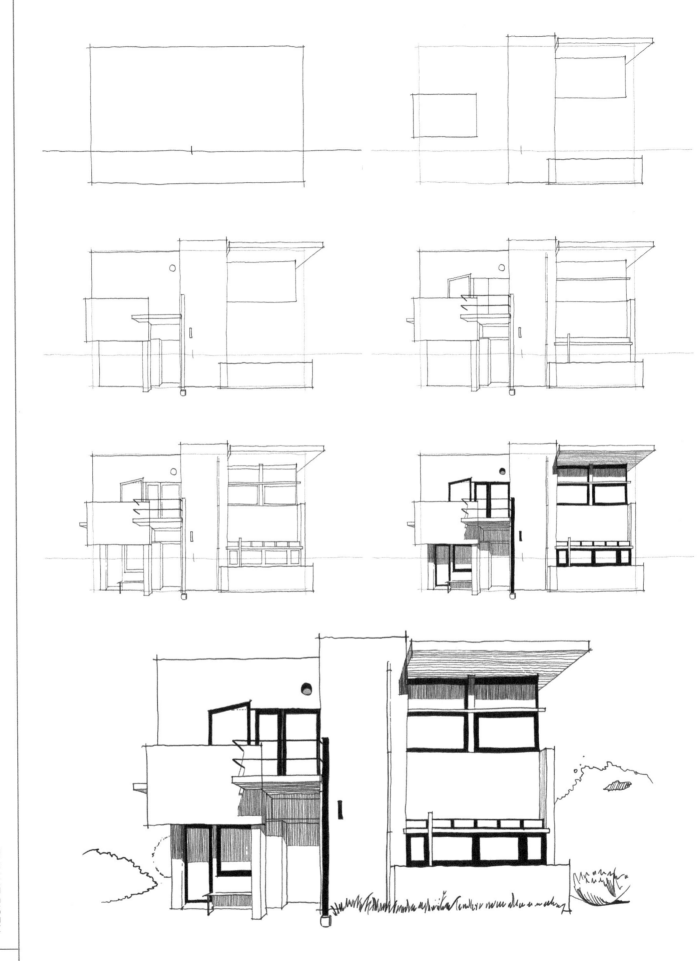

RIETVELD SCHRÖDER HOUSE / GERRIT RIETVELD | UTRECHT, NETHERLANDS

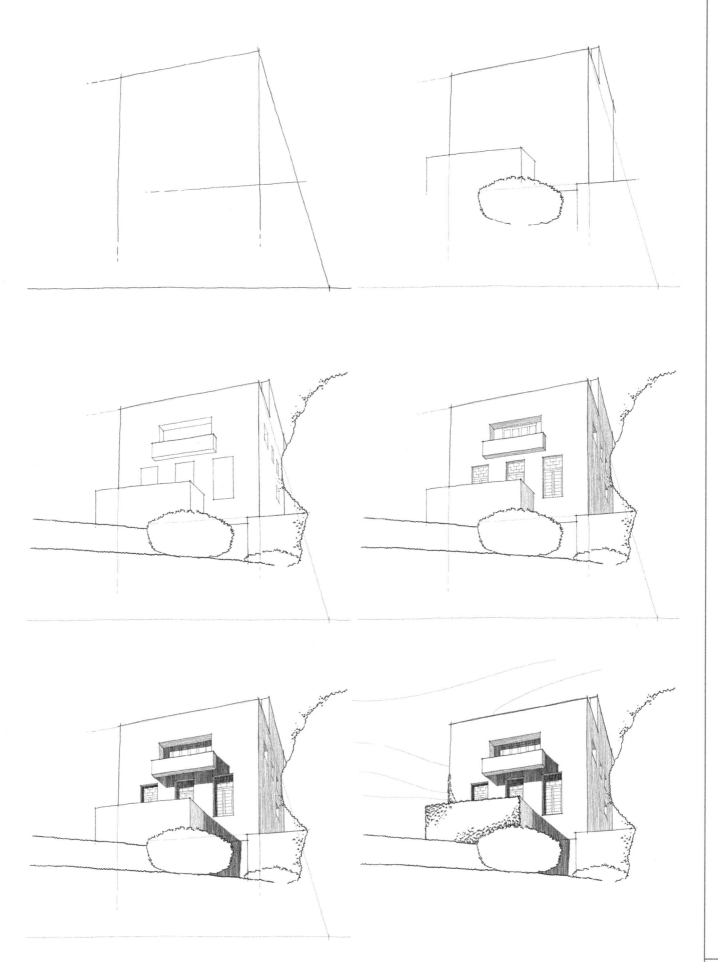

VILLA MUELLER / ADOLF LOOS | PRAGUE, CZECH REPUBLIC

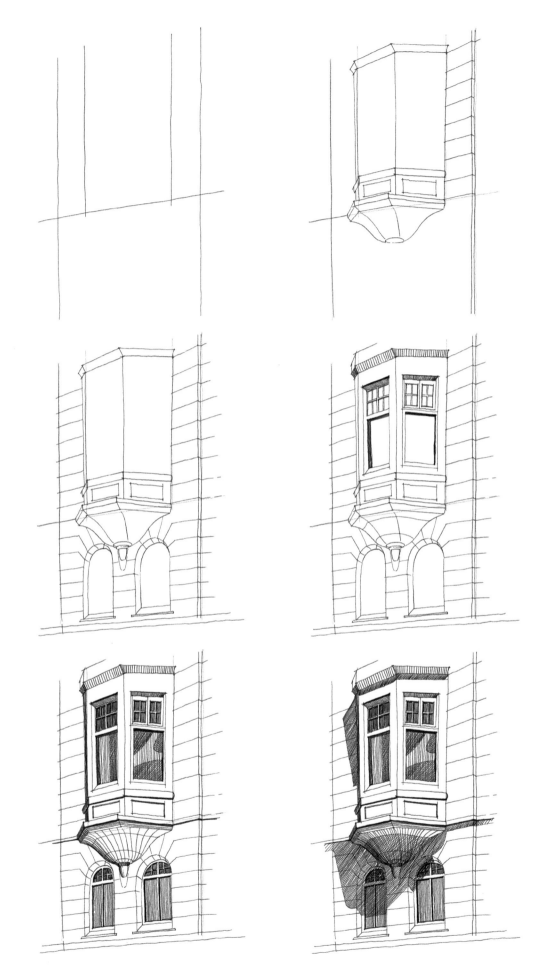

RESIDENTIAL

BAY WINDOW DETAIL | COPENHAGEN, DENMARK

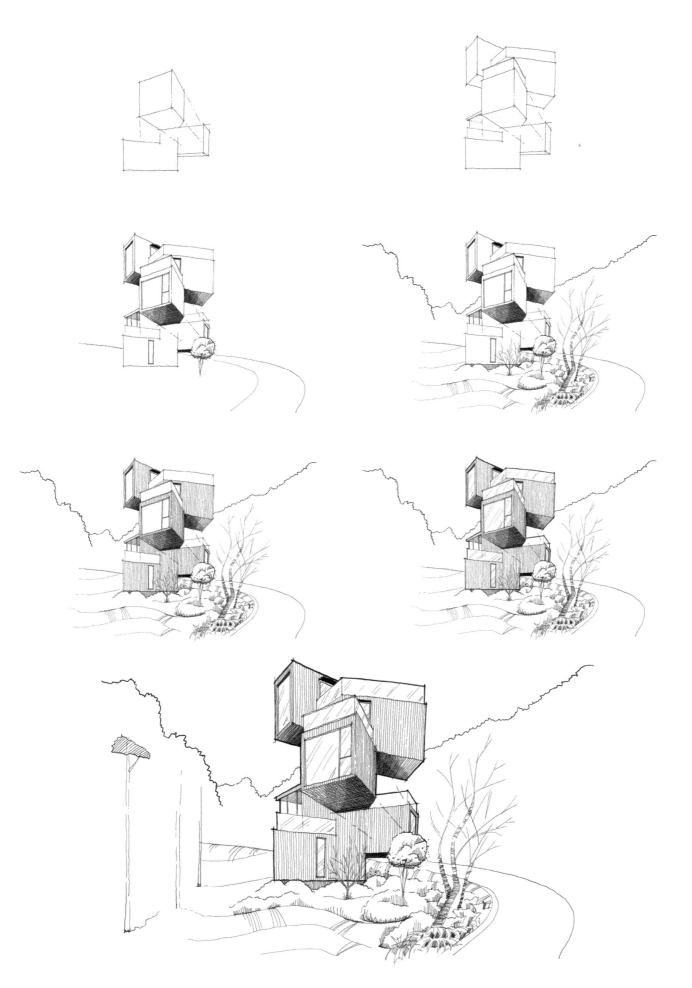

QIYUNSHAN TREE HOUSE HOTEL / BENGO STUDIO | CHINA

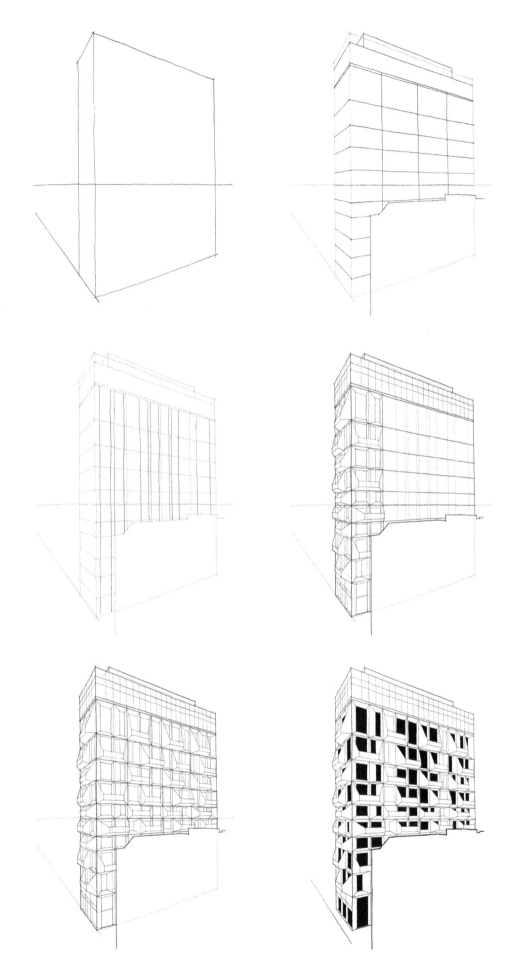

RESIDENTIAL

THE SILO / COBE | COPENHAGEN, DENMARK

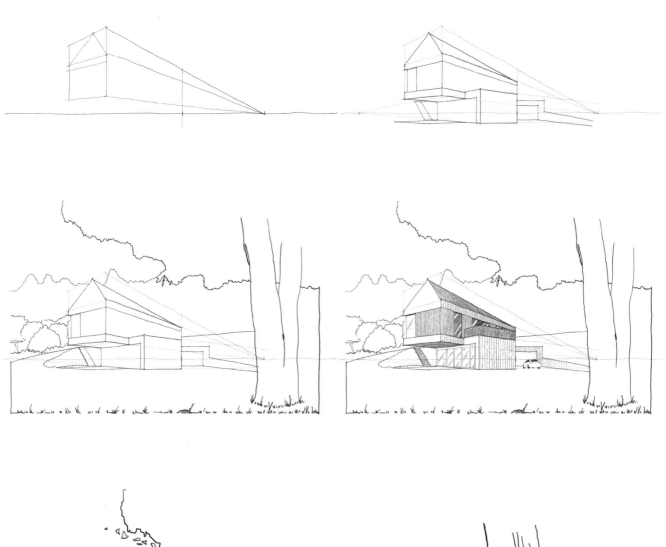

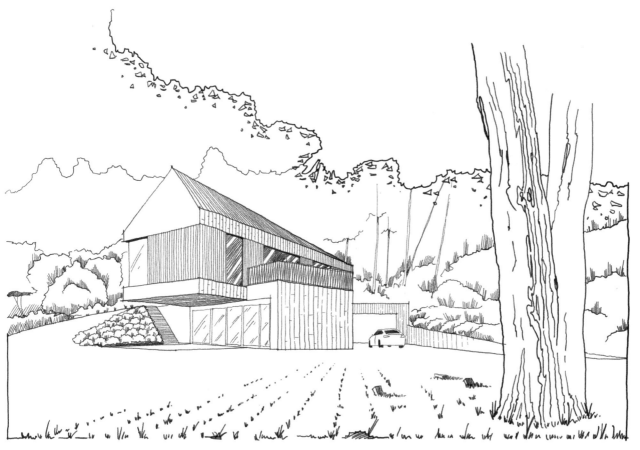

VALLEY VILLA / ARCHES | VILNIUS, LITHUANIA

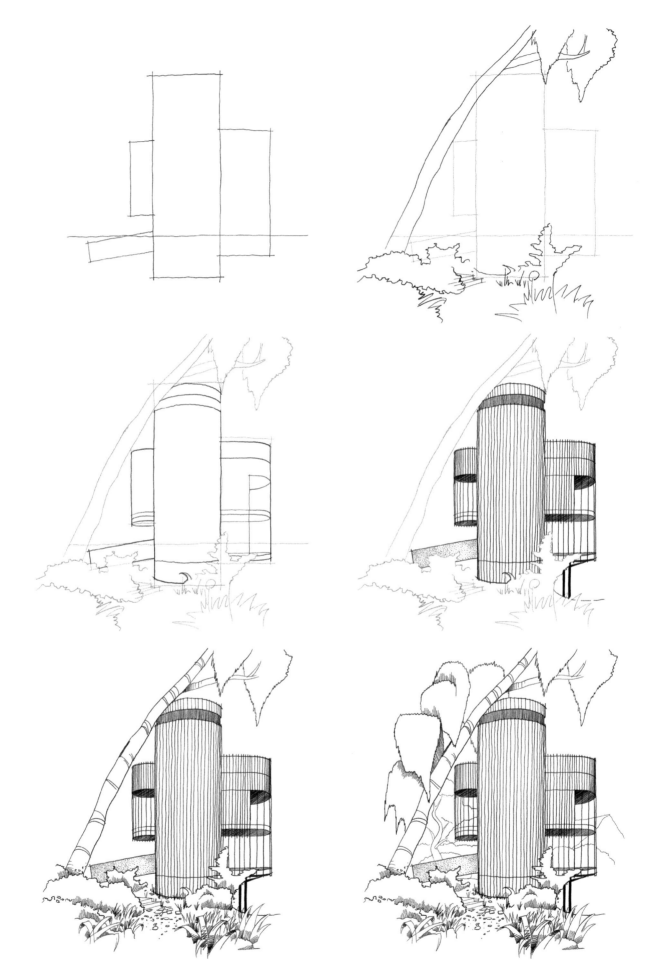

TREE HOUSE / MALAN VORSTER | CAPE TOWN, SOUTH AFRICA

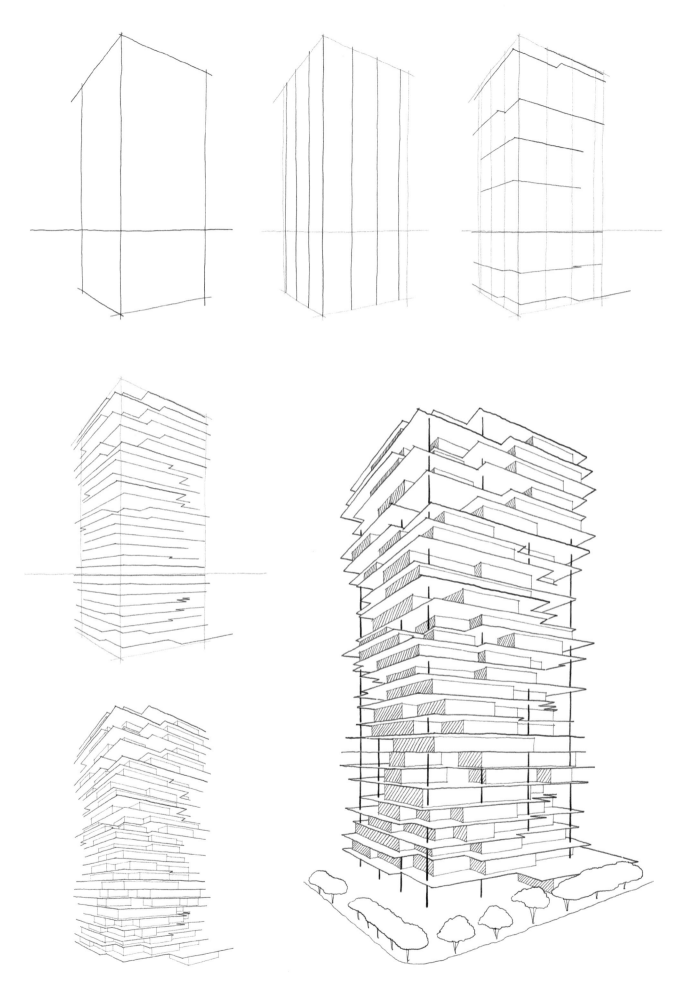

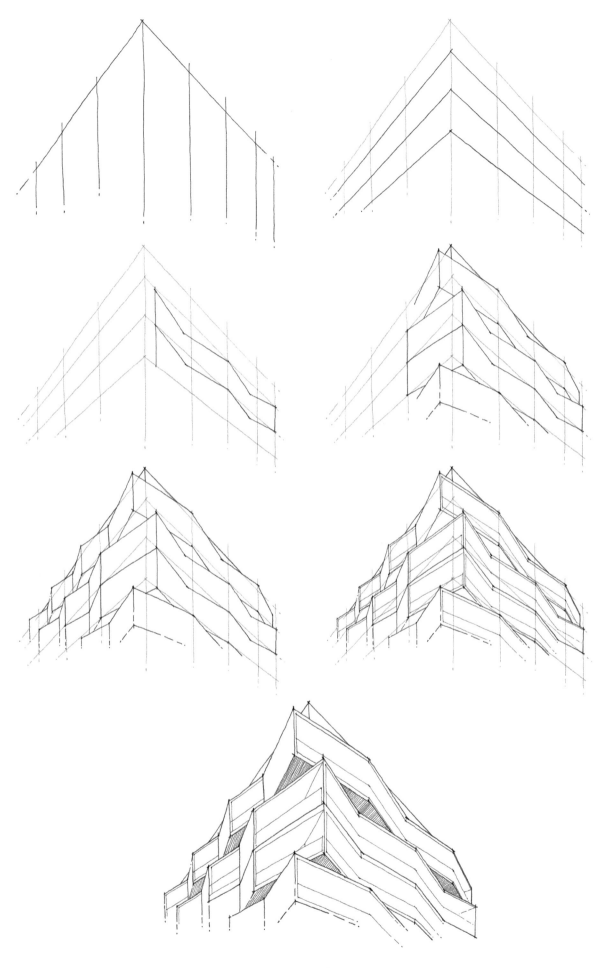

DYEJI / COSTA LOPES | LUANDA, ANGOLA

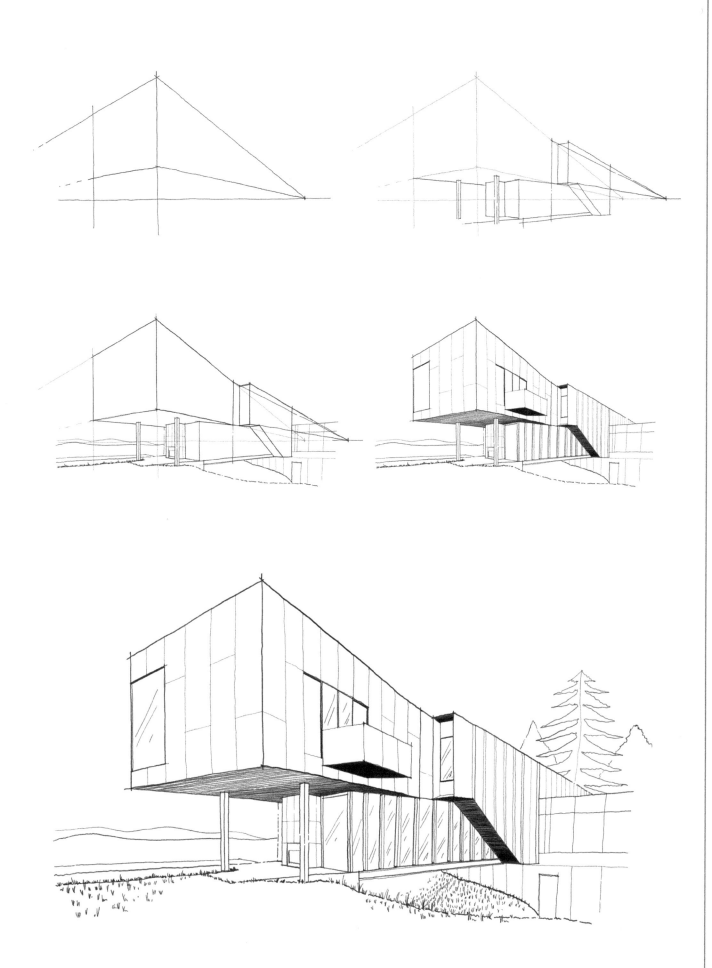

RIMROCK / OLSON KUNDIG | SPOKANE, WASHINGTON, USA

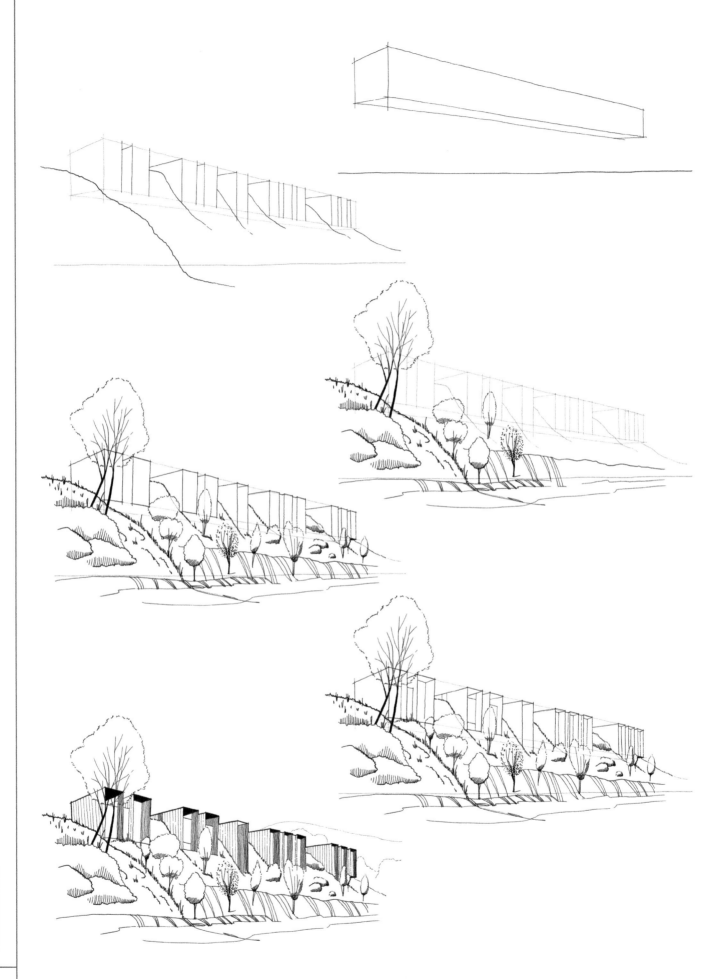

RURAL HOUSE / RCR ARQUITECTES | LA GARROTXA, SPAIN

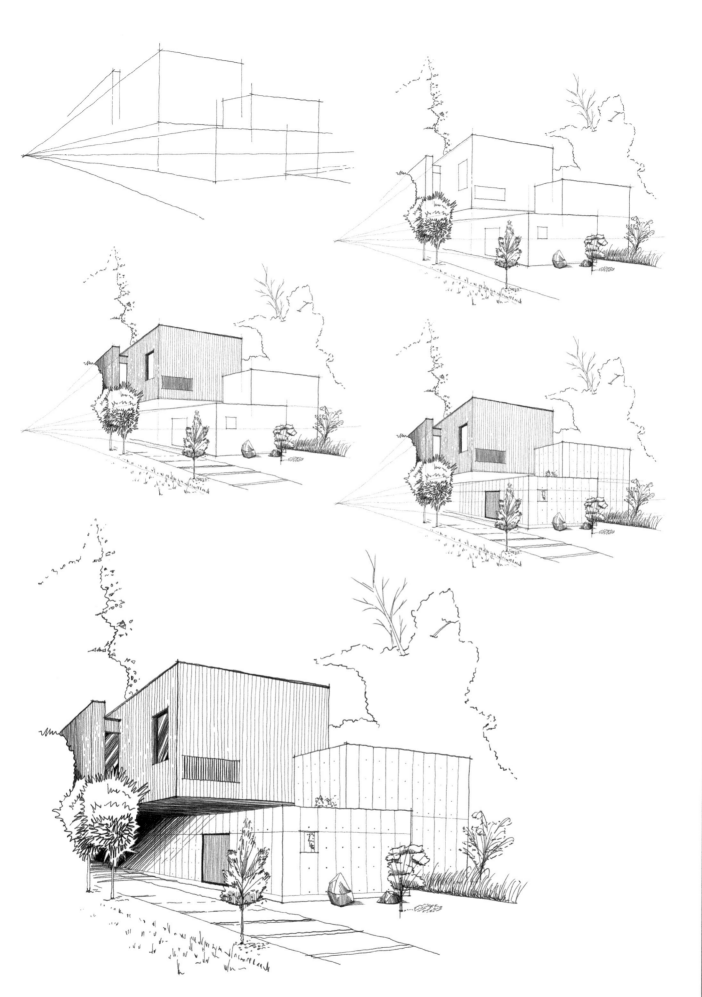

CONCRETE BOX HOUSE / ROBERTSON DESIGN | HOUSTON, TEXAS, USA

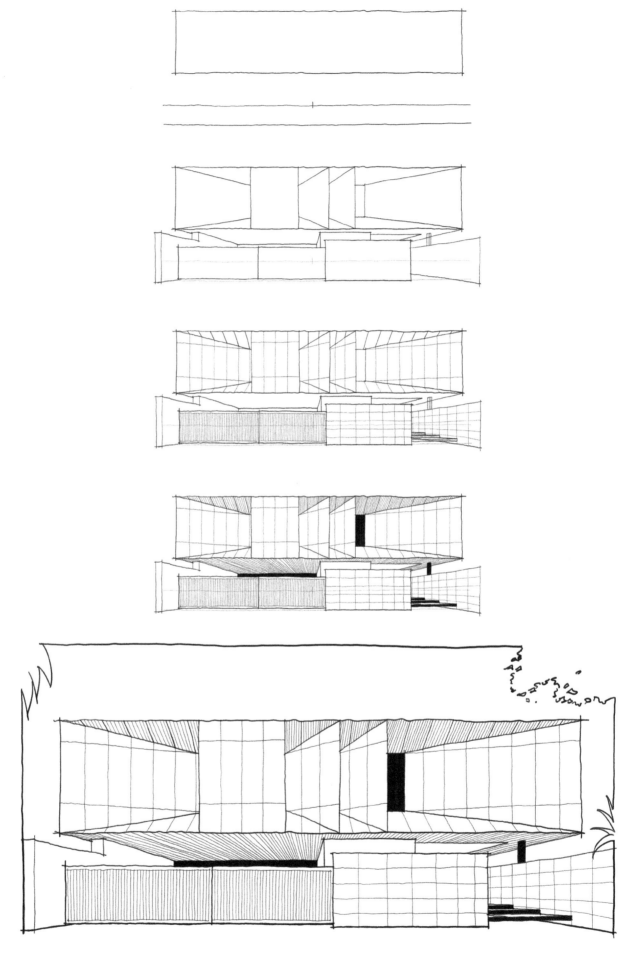

MARBLE HOUSE / OPENBOX ARCHITECTS | BANGKOK, THAILAND

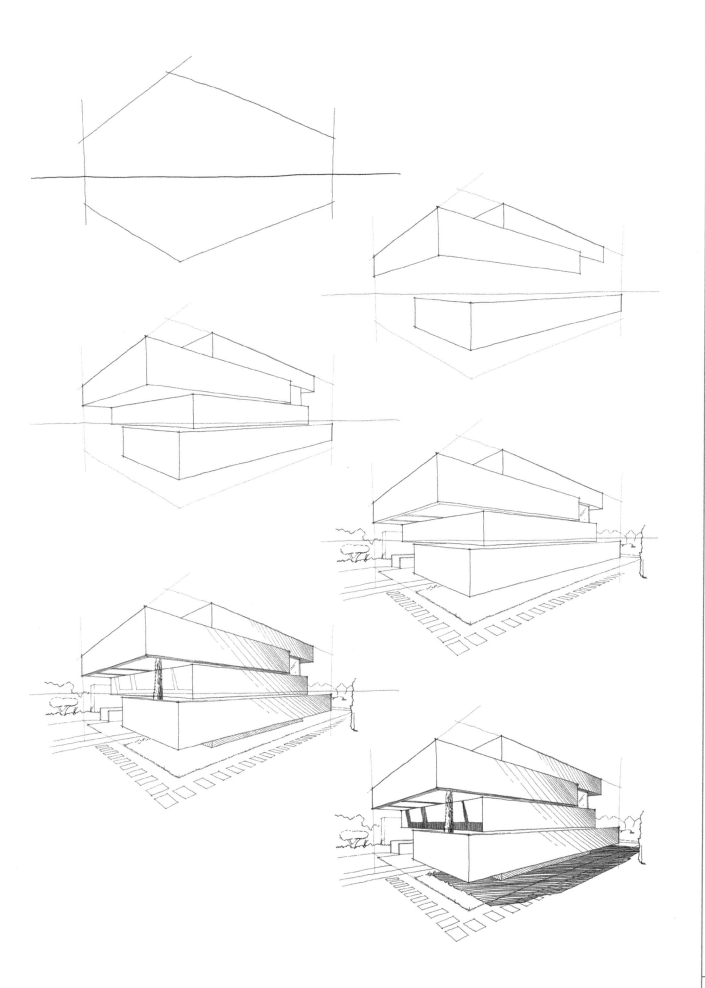

RESIDENTIAL

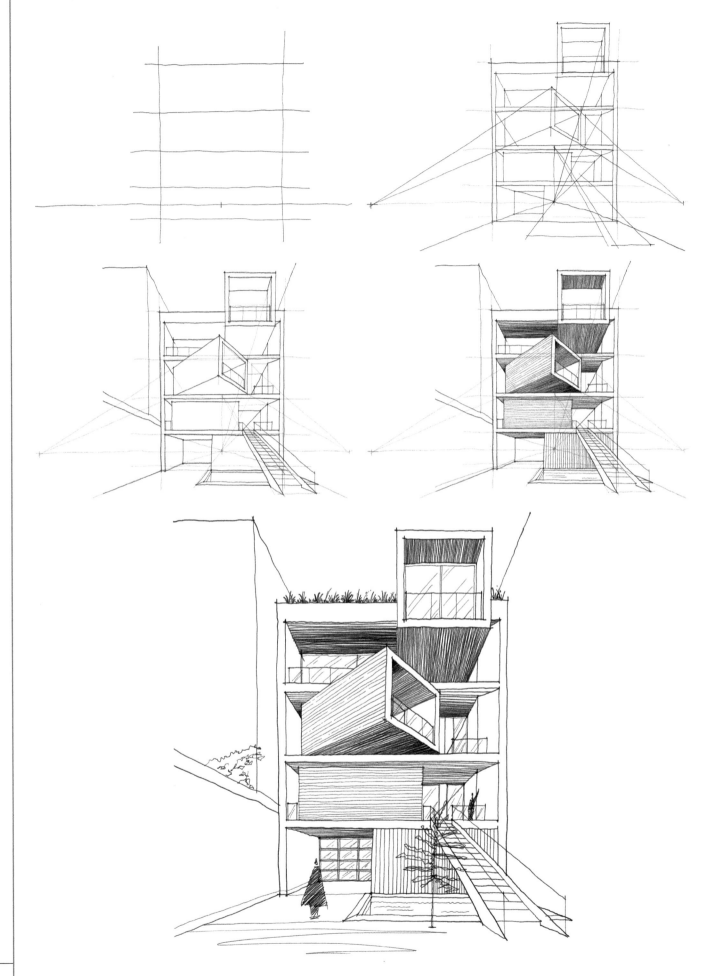

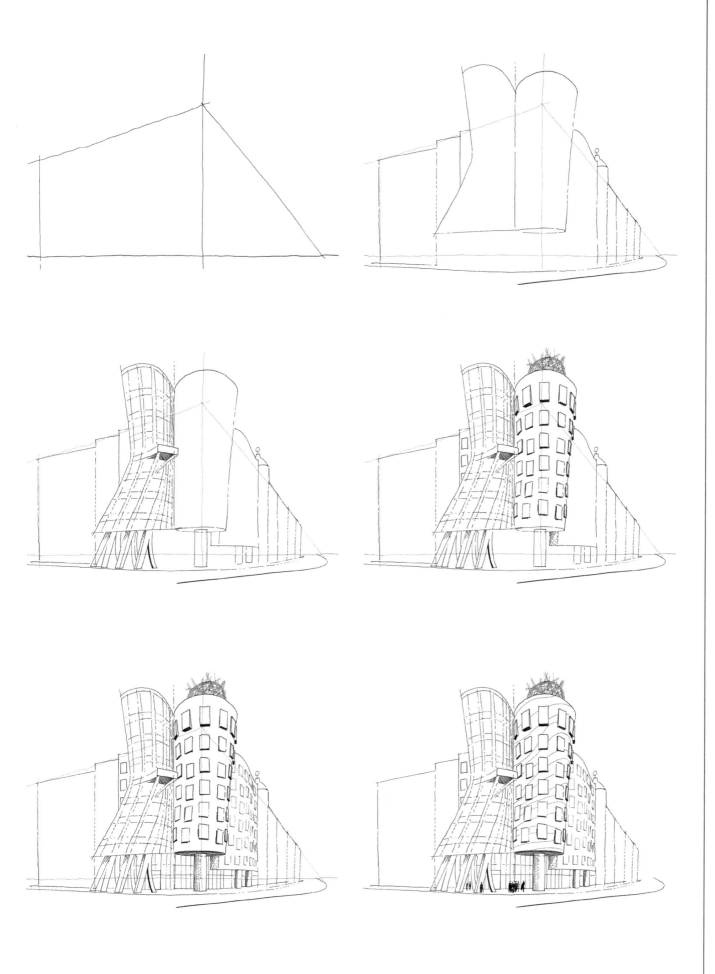

DANCING HOUSE / VLADO MILUNIĆ, FRANK GEHRY | PRAGUE, CZECH REPUBLIC

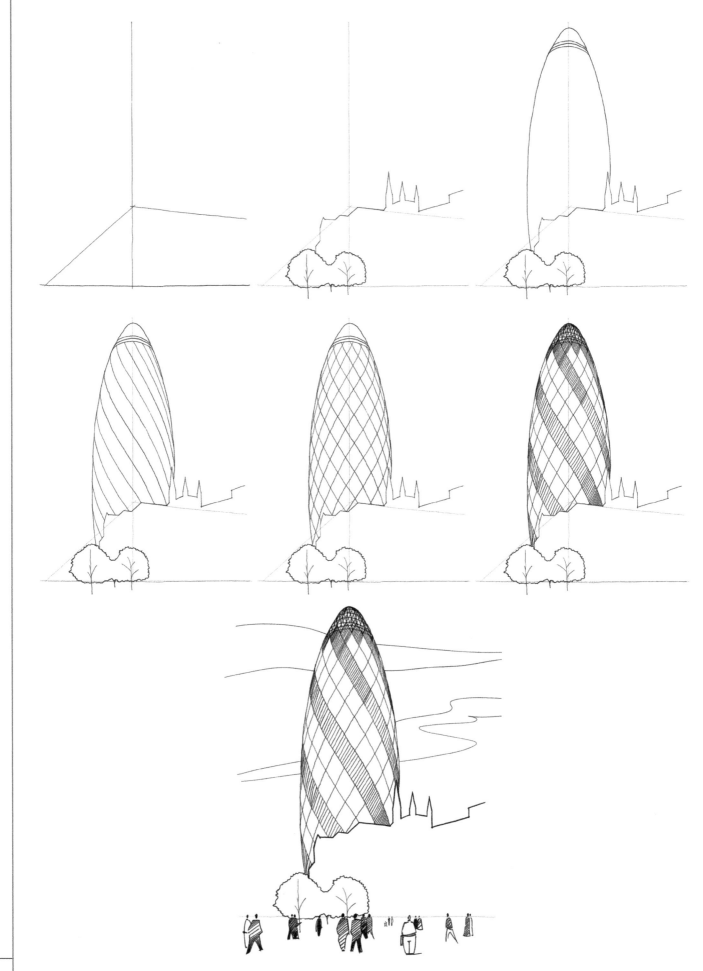

THE GHERKIN / FOSTER + PARTNERS | LONDON

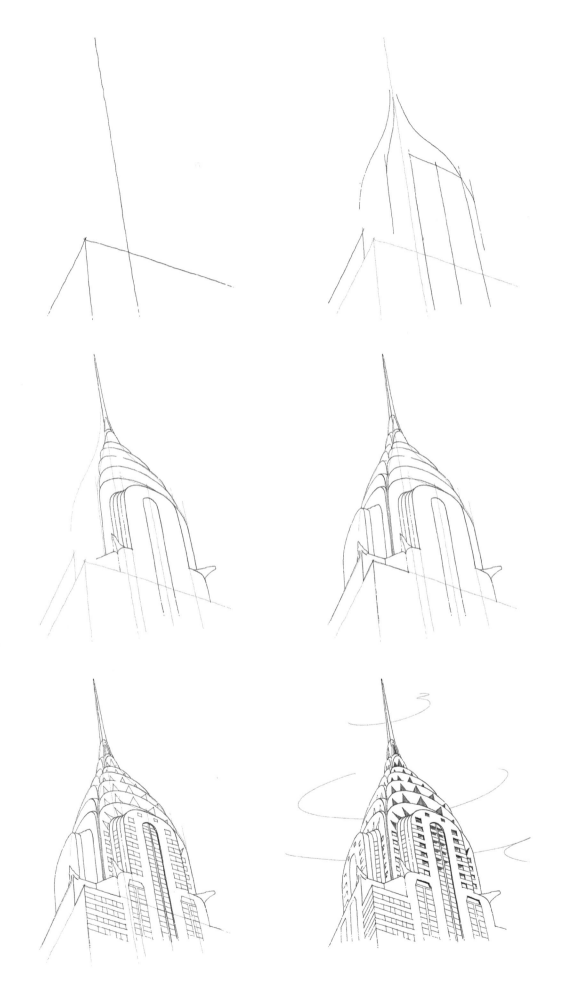

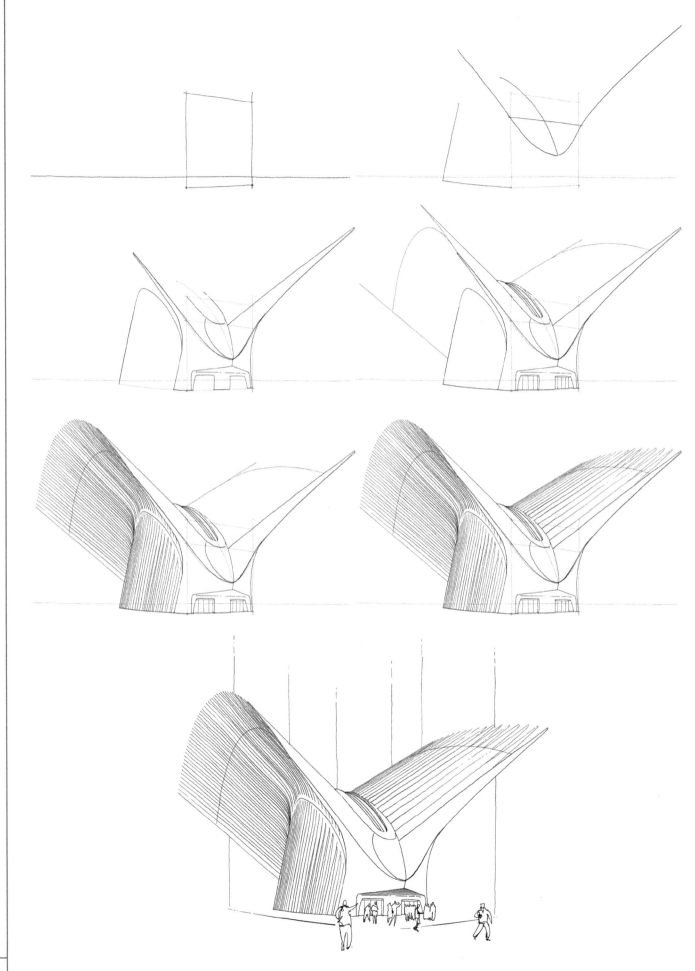

OCULUS, WORLD TRADE CENTER / SANTIAGO CALATRAVA | NEW YORK CITY

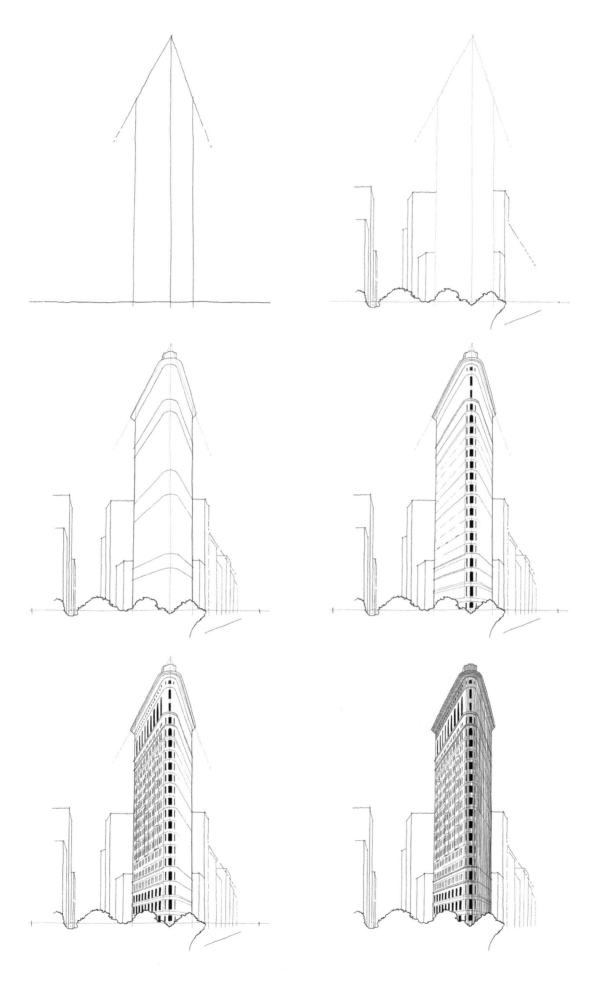

THE FLATIRON BUILDING / DANIEL BURNHAM | NEW YORK CITY

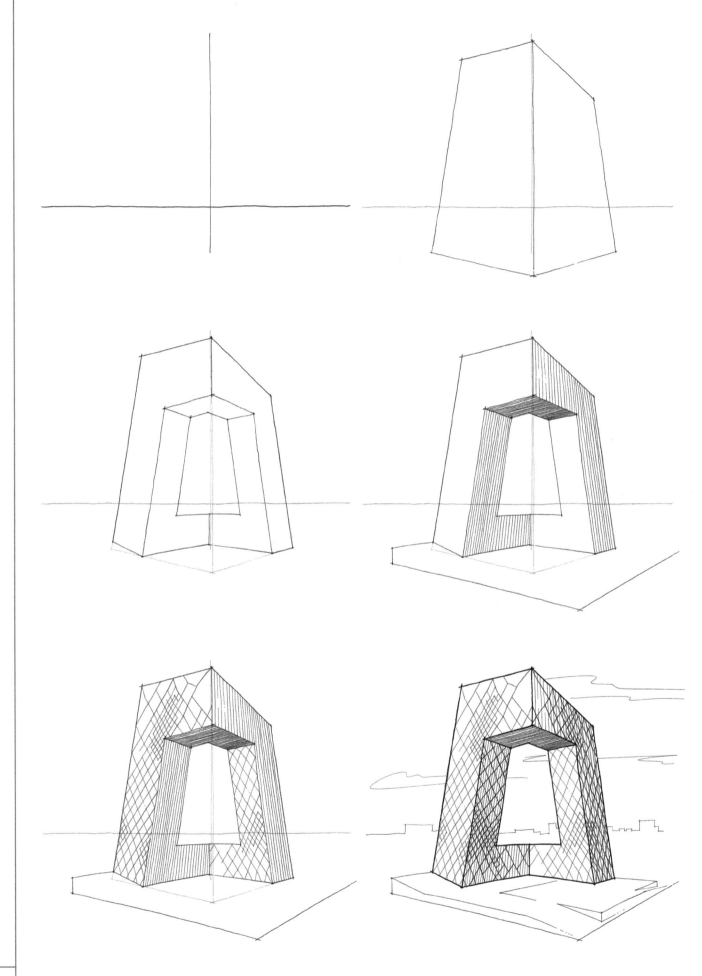

CENTRAL RADIO & TV TOWER / PAULUS SNOEREN | BEIJING

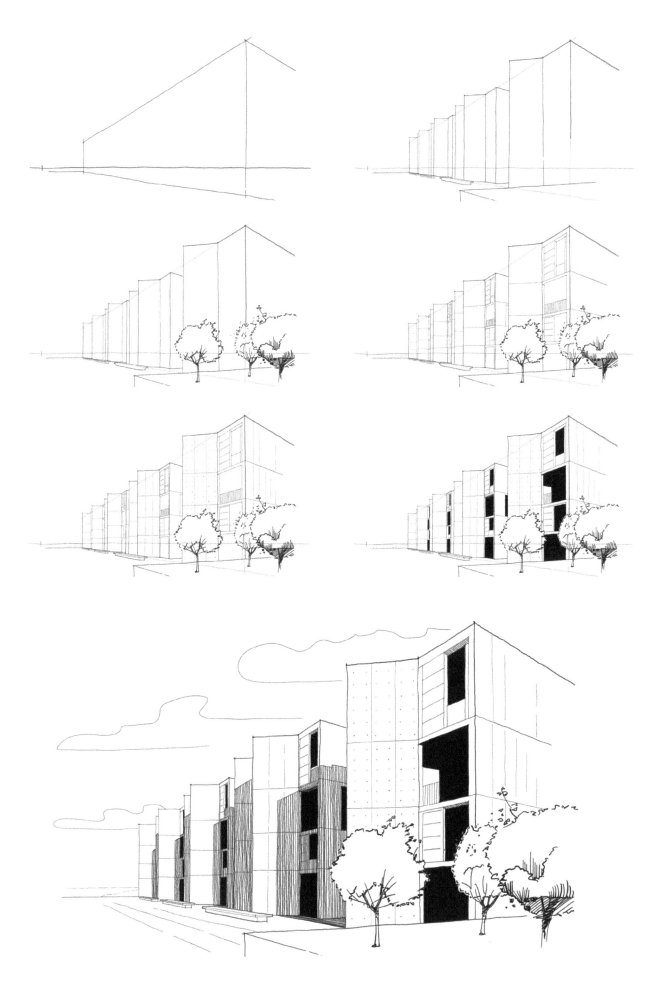

SALK INSTITUTE FOR BIOLOGICAL STUDIES / LOUIS KAHN | LA JOLLA, CALIFORNIA, USA

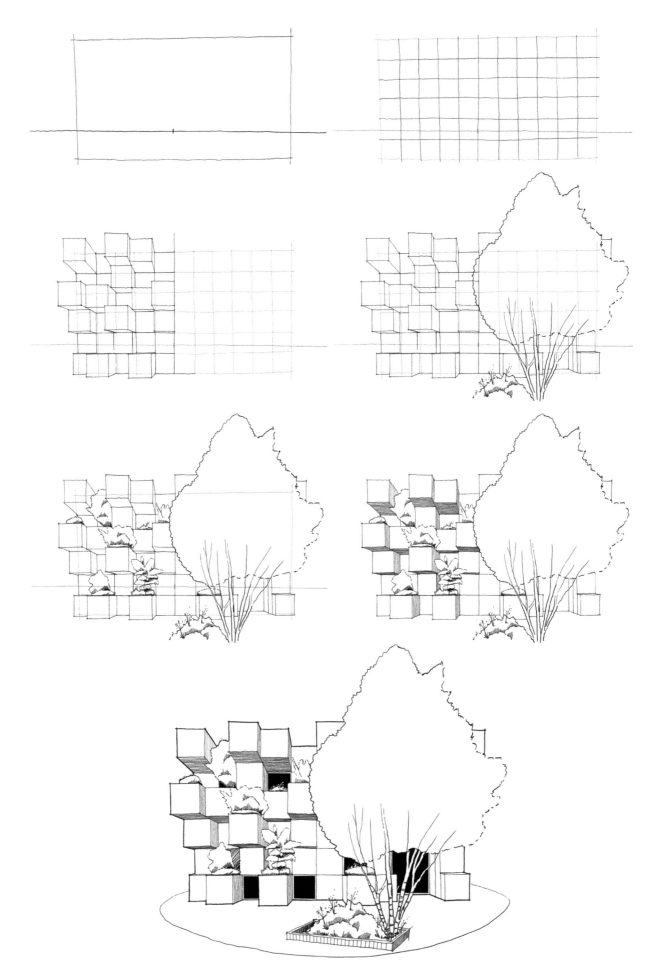

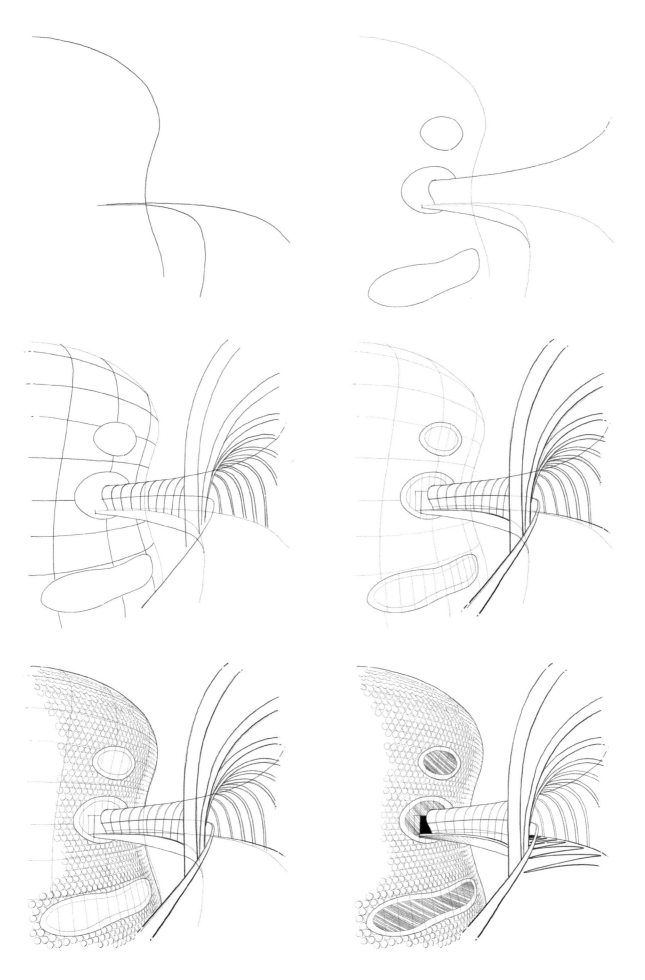

SELFRIDGES BUILDING, BIRMINGHAM / JAN KAPLICKY | BIRMINGHAM, ENGLAND

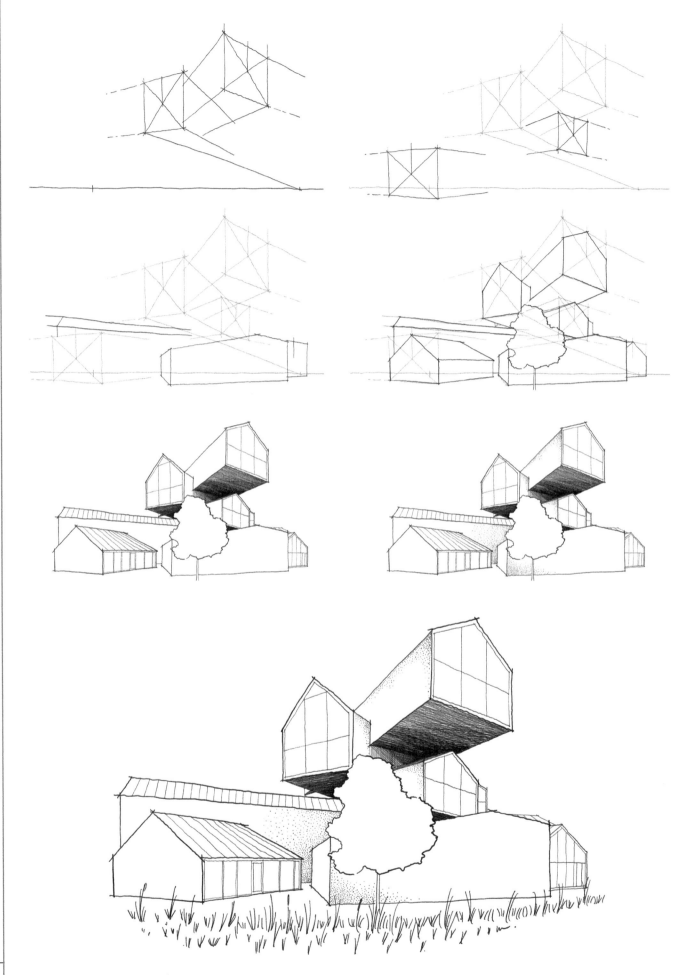

VITRAHAUS / HERZOG & DE MEURON | WEIL AM RHEIN, GERMANY

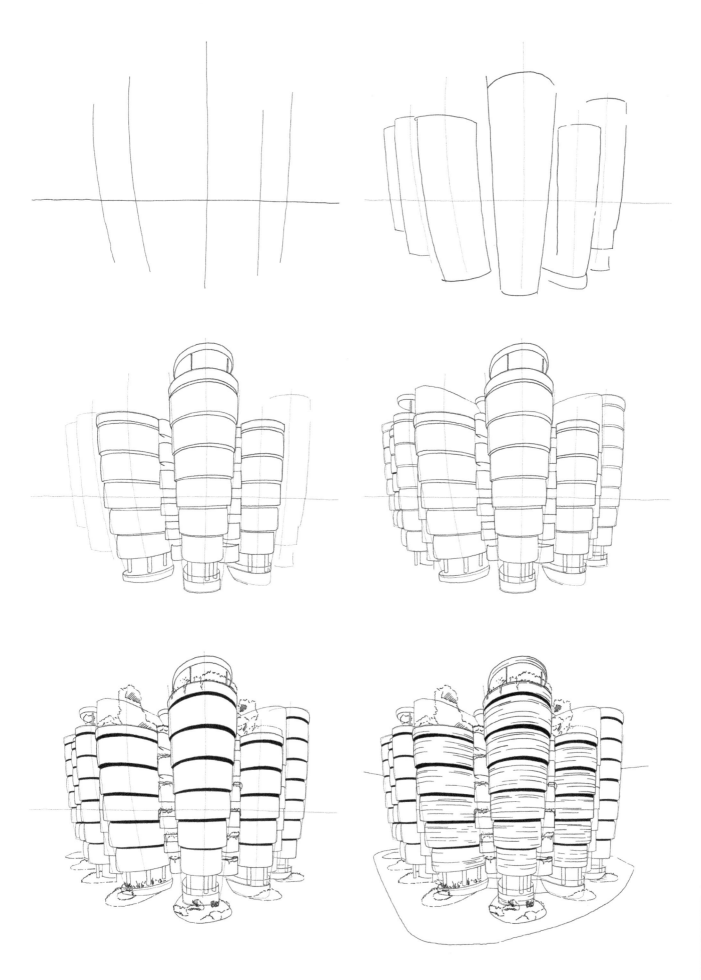

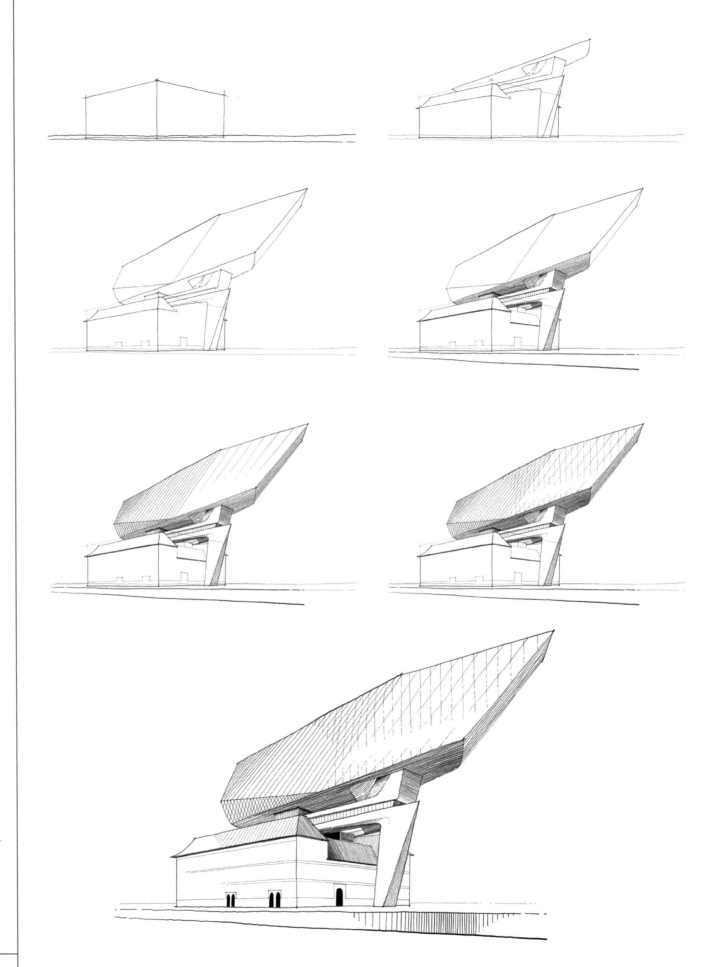

ANTWERP PORT HOUSE / ZAHA HADID ARCHITECTS | ANTWERP, BELGIUM

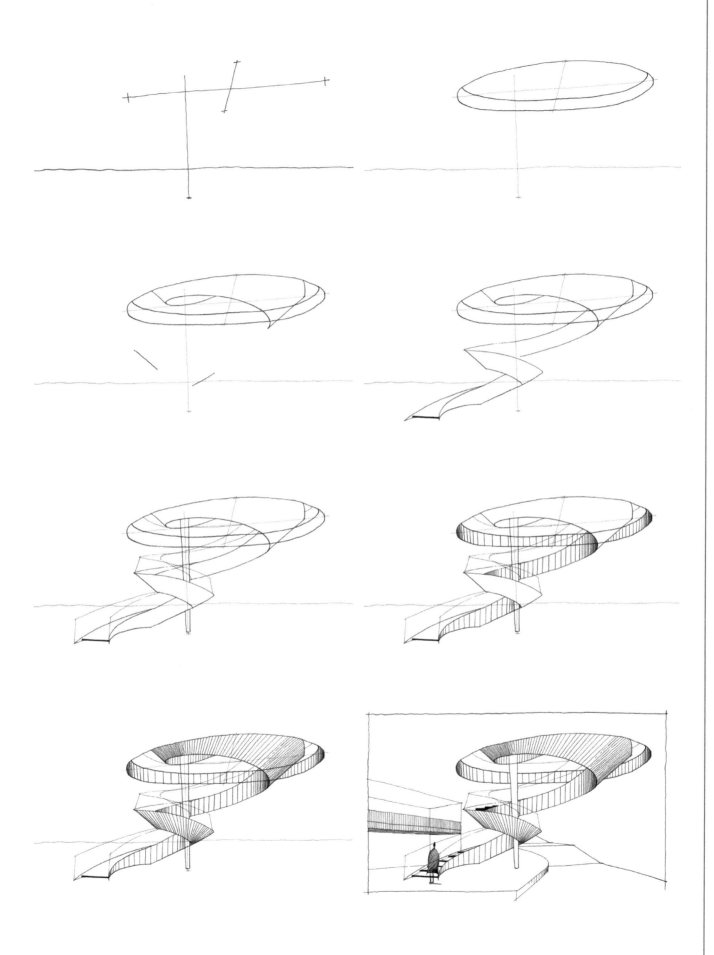

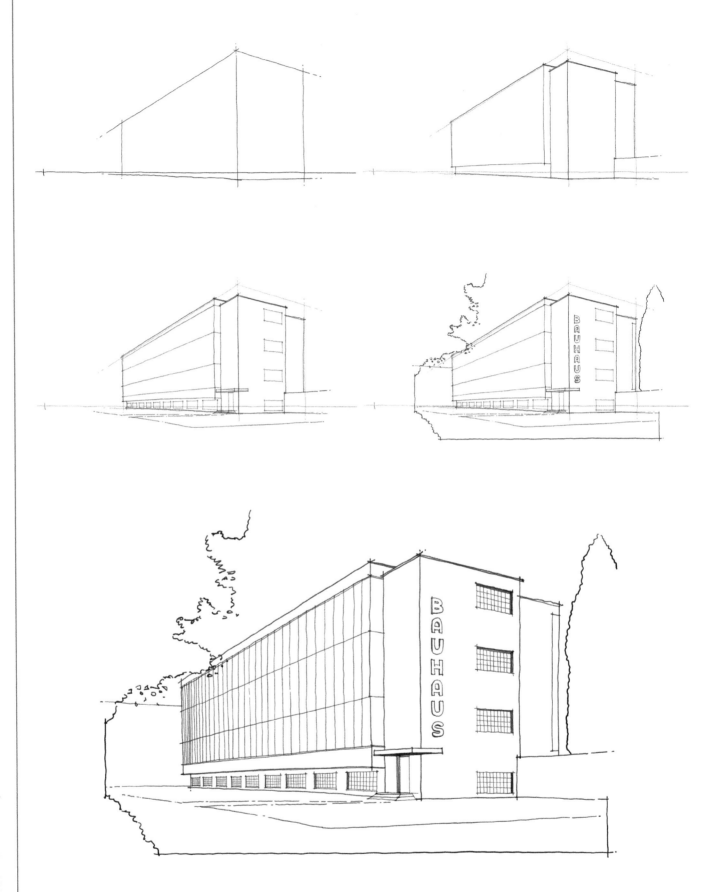

BAUHAUS / WALTER GROPIUS | DESSAU, GERMANY

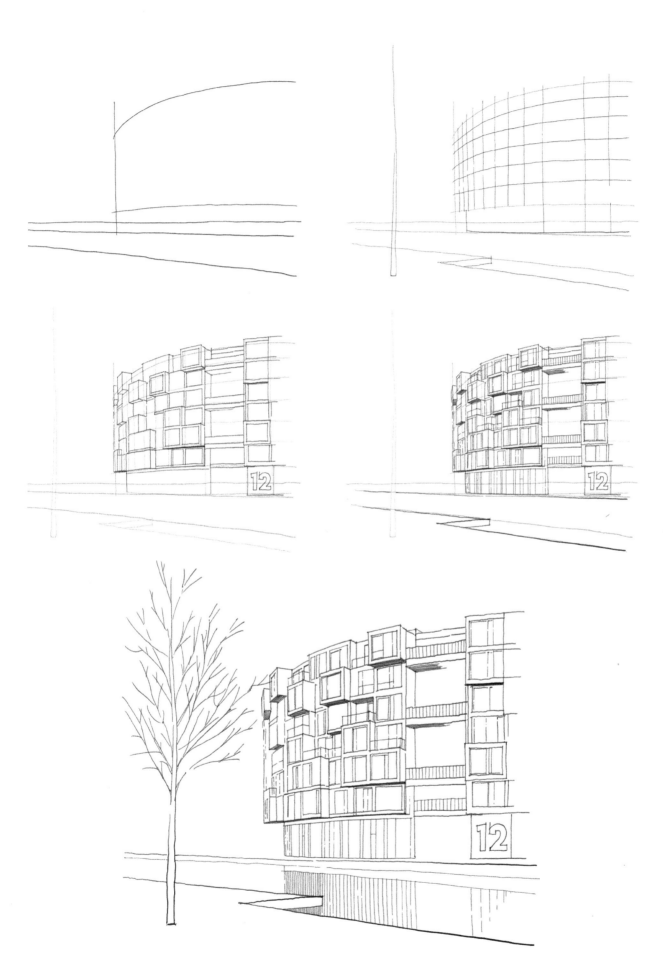

TIETGENKOLLEGIET / LUNDGAARD & TRANBERG | COPENHAGEN

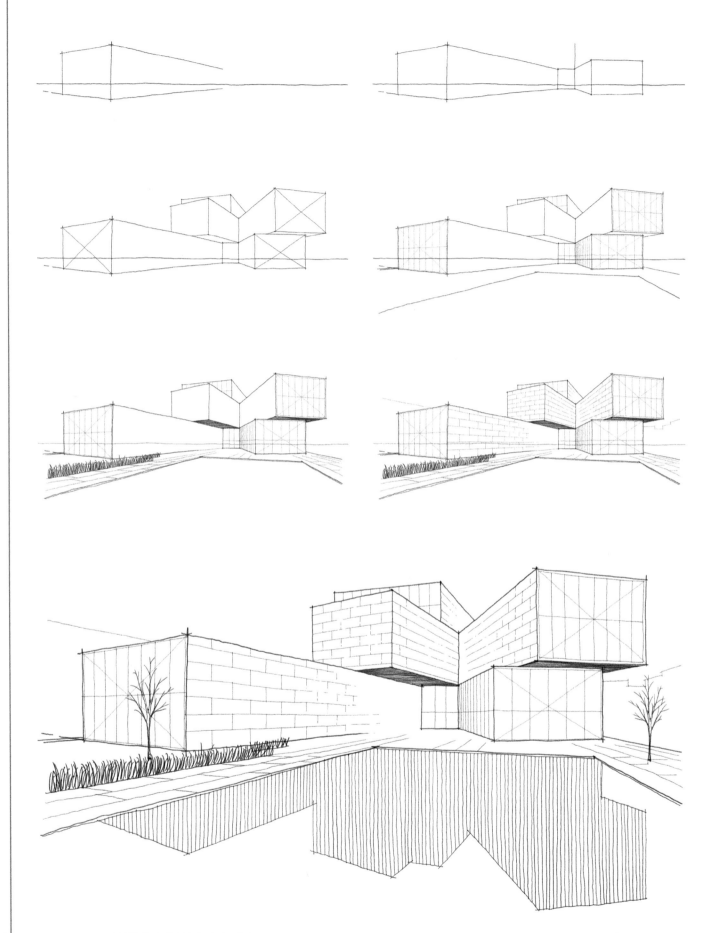

INSTITUTE FOR CONTEMPORARY ART, VIRGINIA COMMONWEALTH UNIVERSITY /
STEVEN HOLL ARCHITECTS | RICHMOND, VIRGINIA, USA

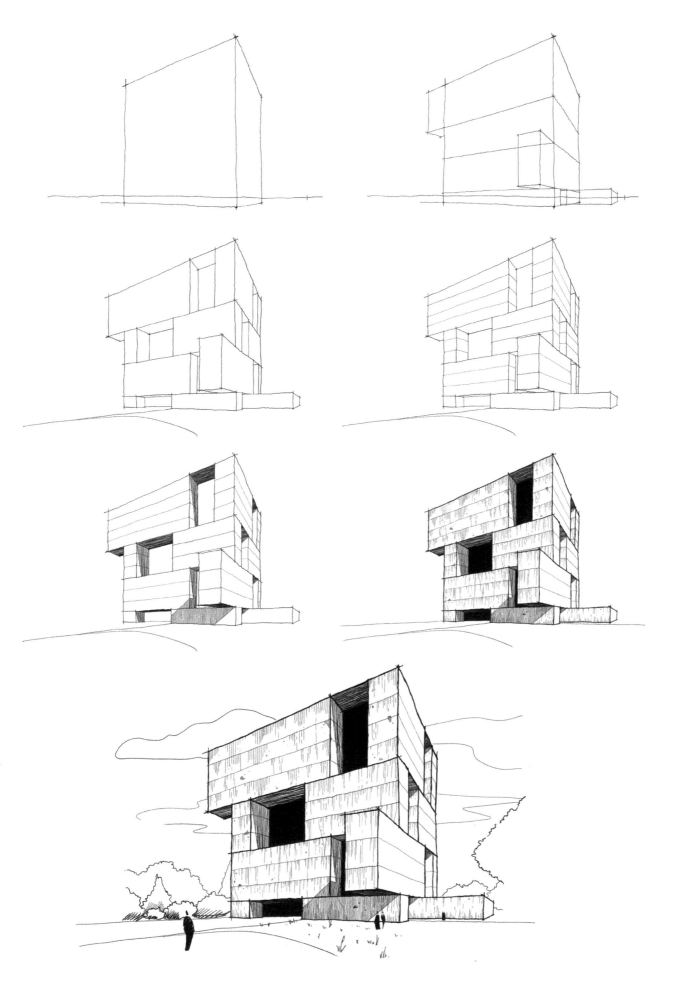

INNOVATION CENTER, UNIVERSITY OF CHILE / ALEJANDRO ARAVENA | SANTIAGO, CHILE

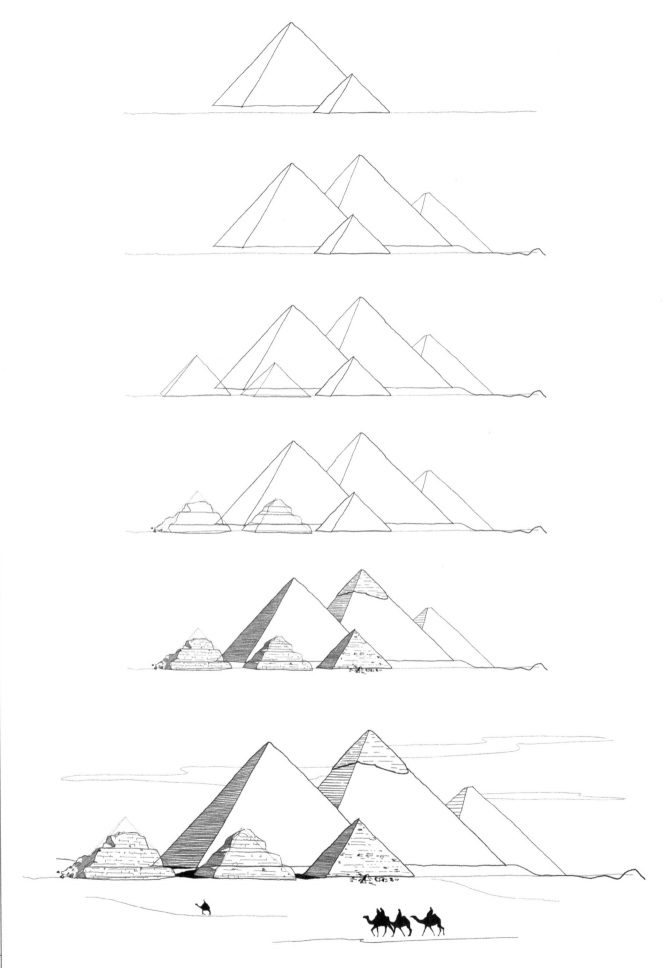

GIZA PYRAMID COMPLEX | GIZA CITY, EGYPT

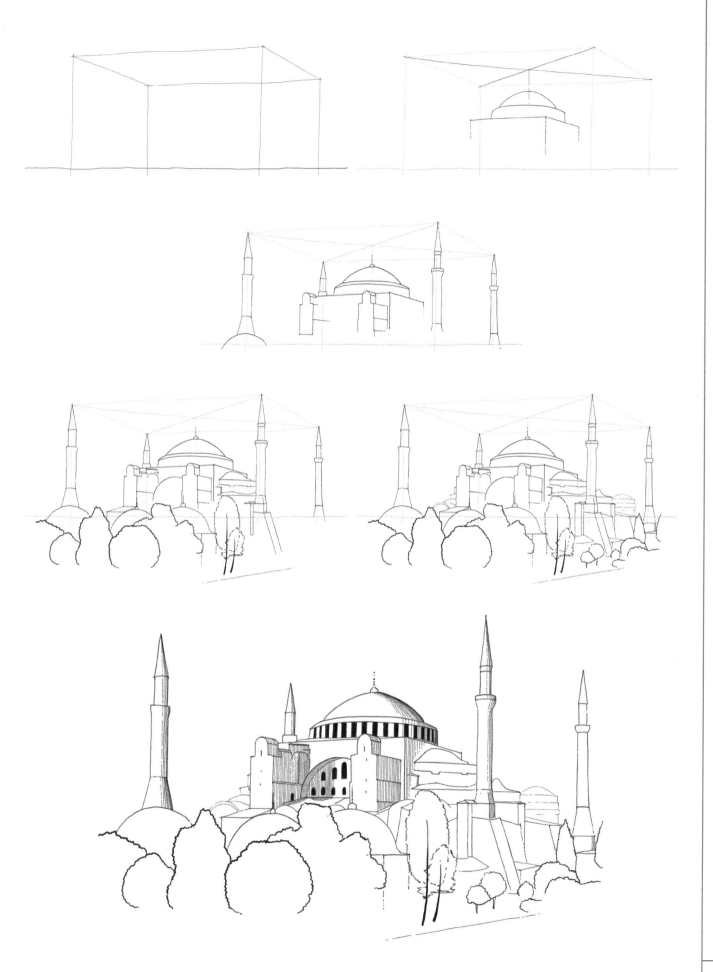

HAGIA SOFIA / ATTRIBUTED TO ISIDORE OF MELITUS, ANTHEMIUS OF TRALLES | ISTANBUL

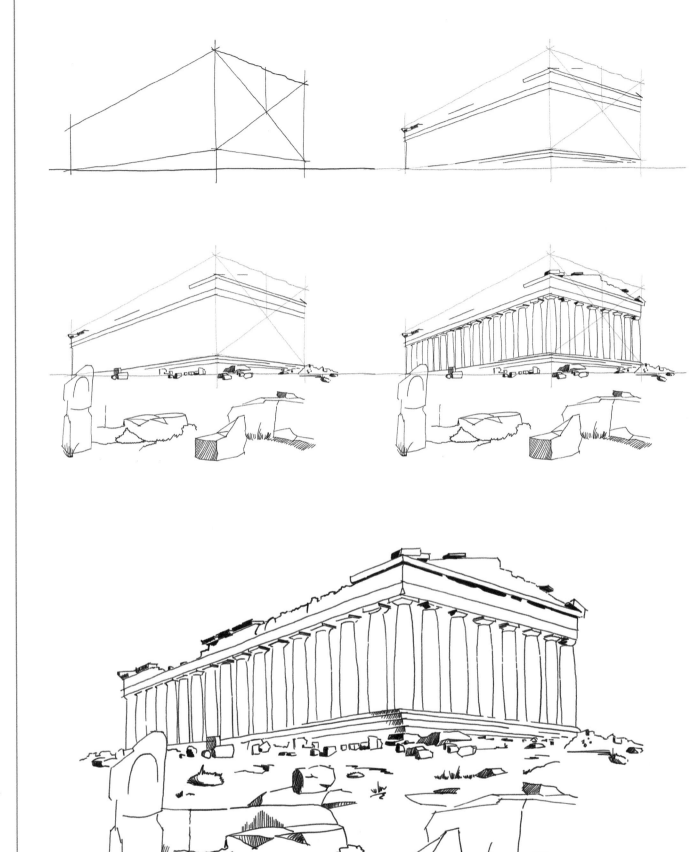

THE PARTHENON, ACROPOLIS OF ATHENS | ATHENS

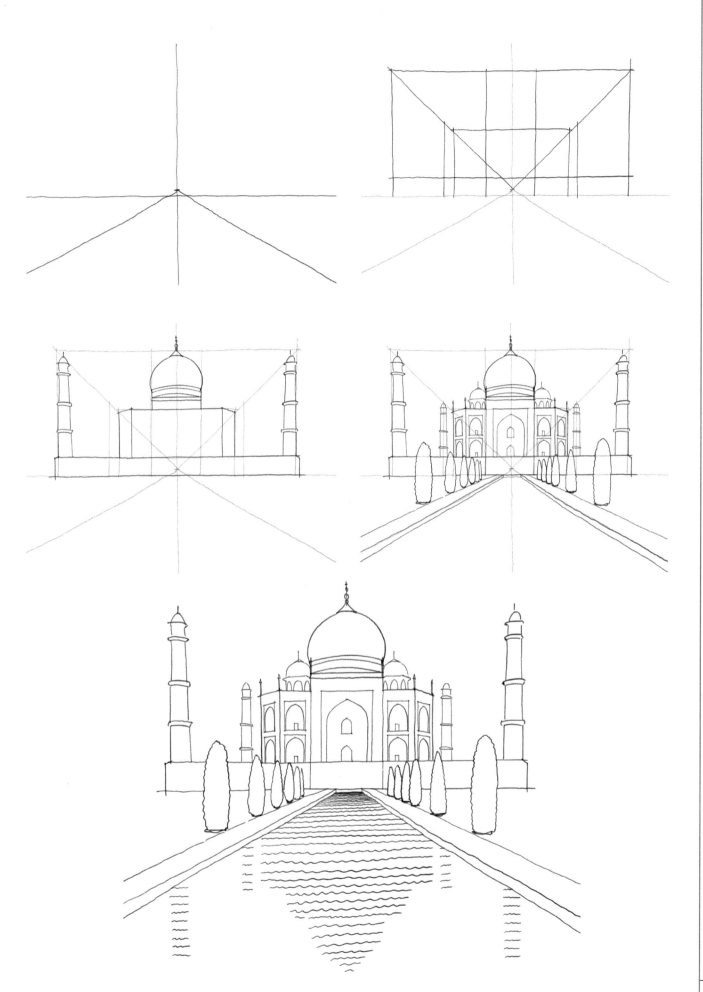

TAJ MAHAL / USTAD AHMAD LAHAURI | AGRA, INDIA

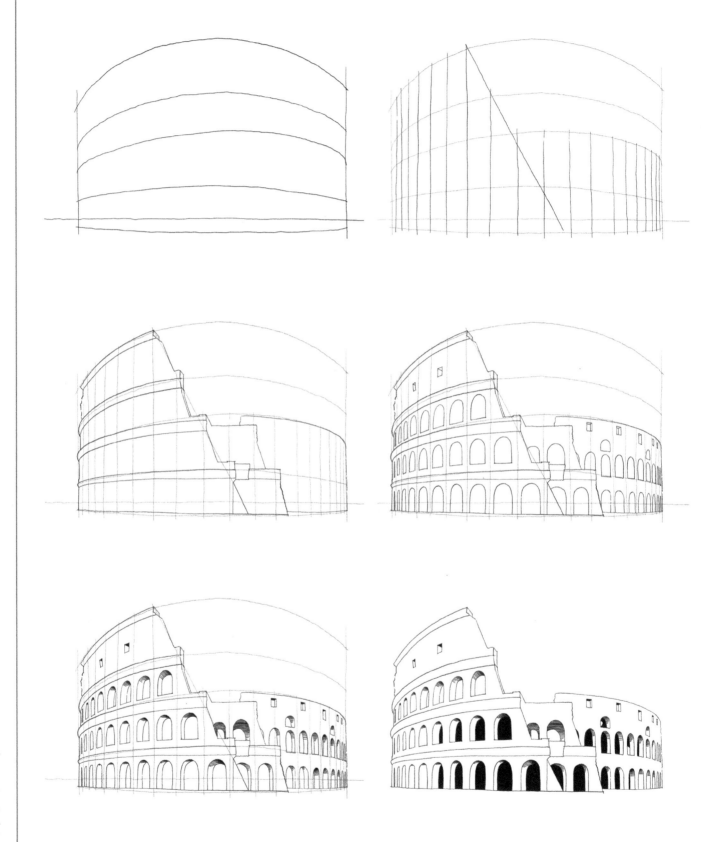

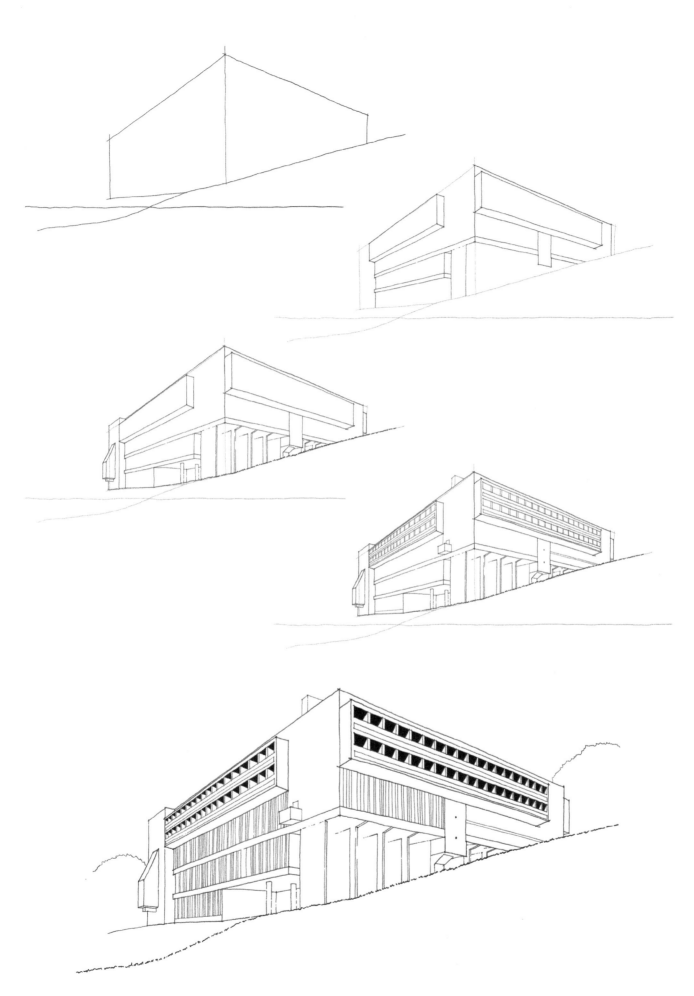

SAINTE MARIE DE LA TOURETTE / LE CORBUSIER | L'ARBRESLE, FRANCE

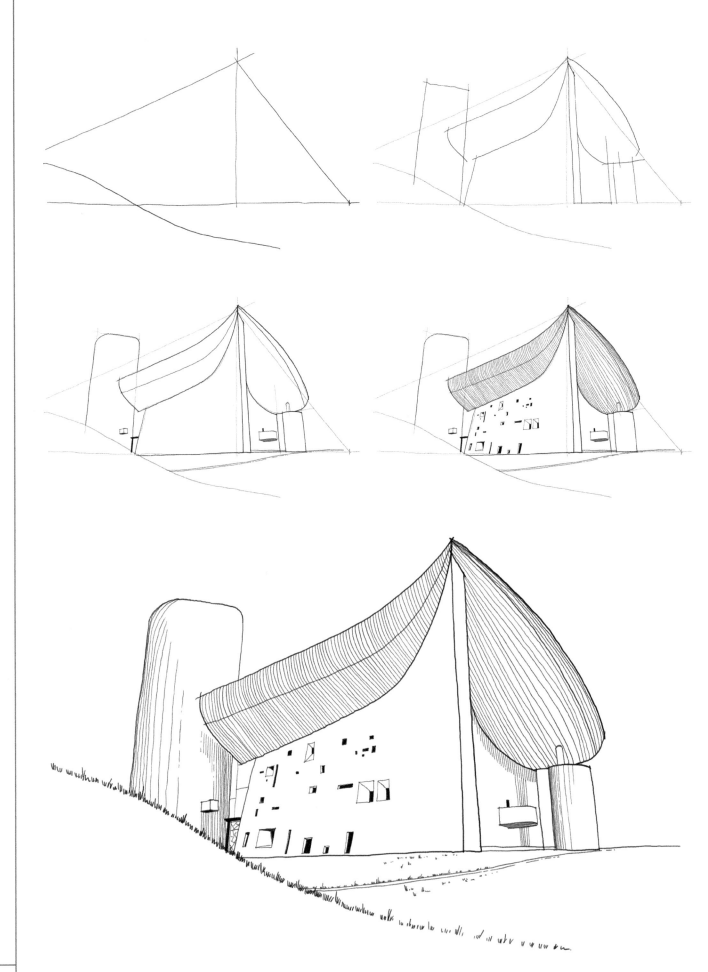

NOTRE-DAME DU HAUT / LE CORBUSIER | RONCHAMP, FRANCE

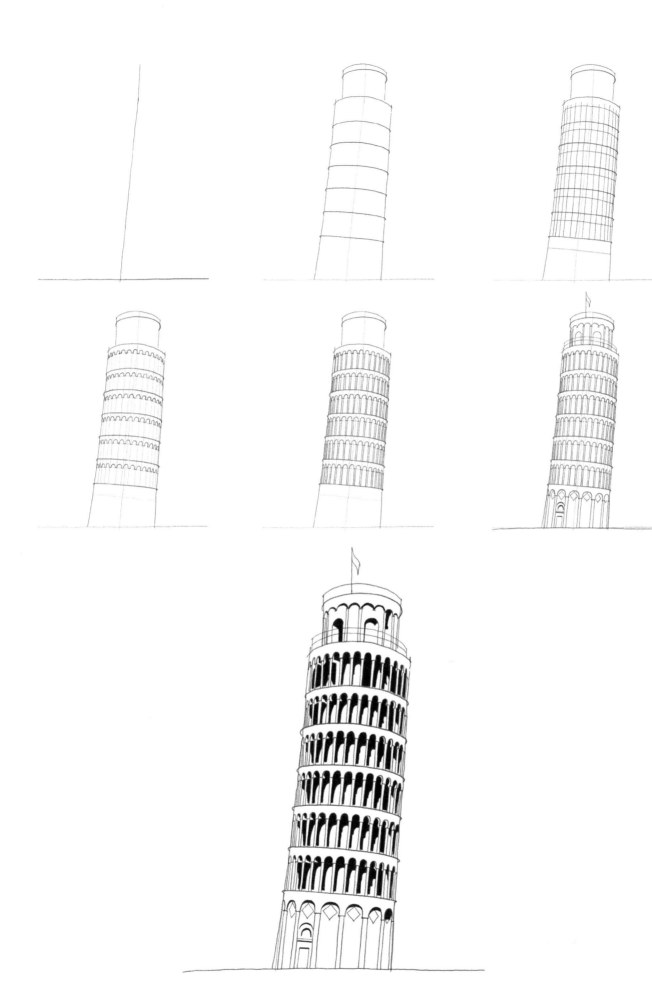

LEANING TOWER OF PISA / ATTRIBUTED TO DIOTISALVO, BONANNO PISANO | PISA, ITALY

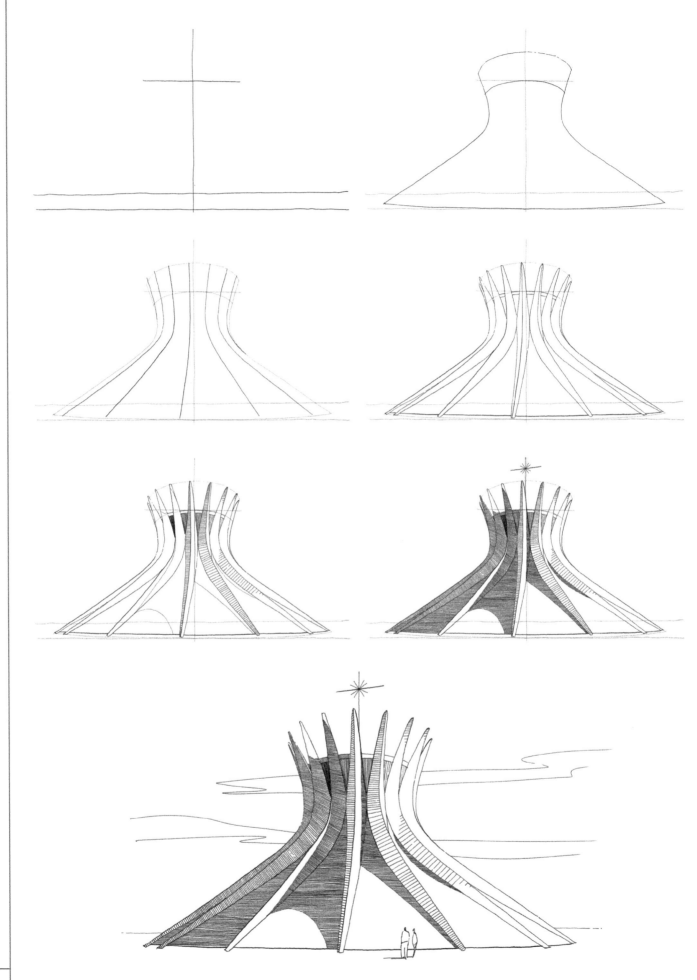

CATHEDRAL OF BRASILIA / OSCAR NIEMEYER | BRASILIA, BRAZIL

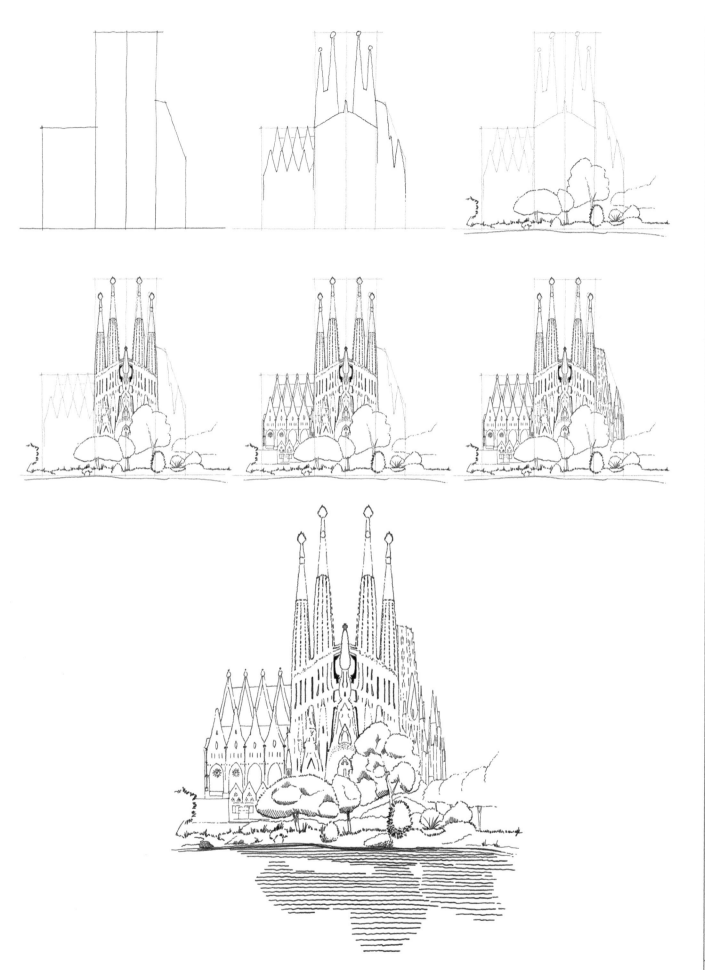

SAGRADA FAMILIA / ANTONI GAUDÍ | BARCELONA

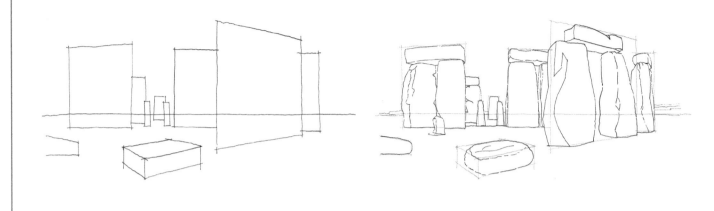

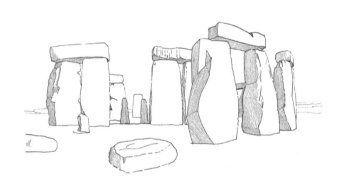
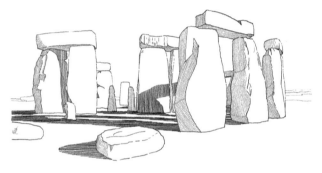

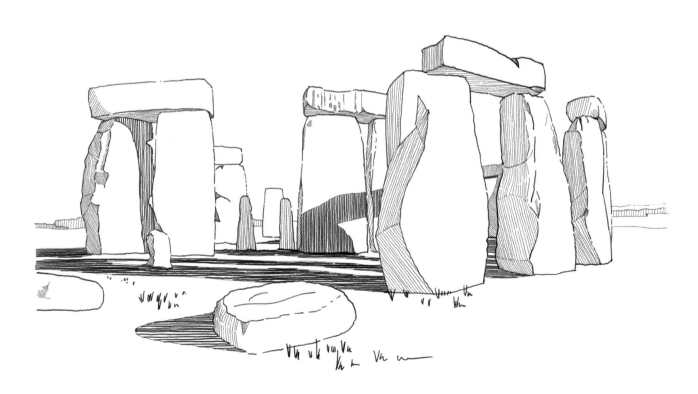

STONEHENGE | WILTSHIRE, ENGLAND

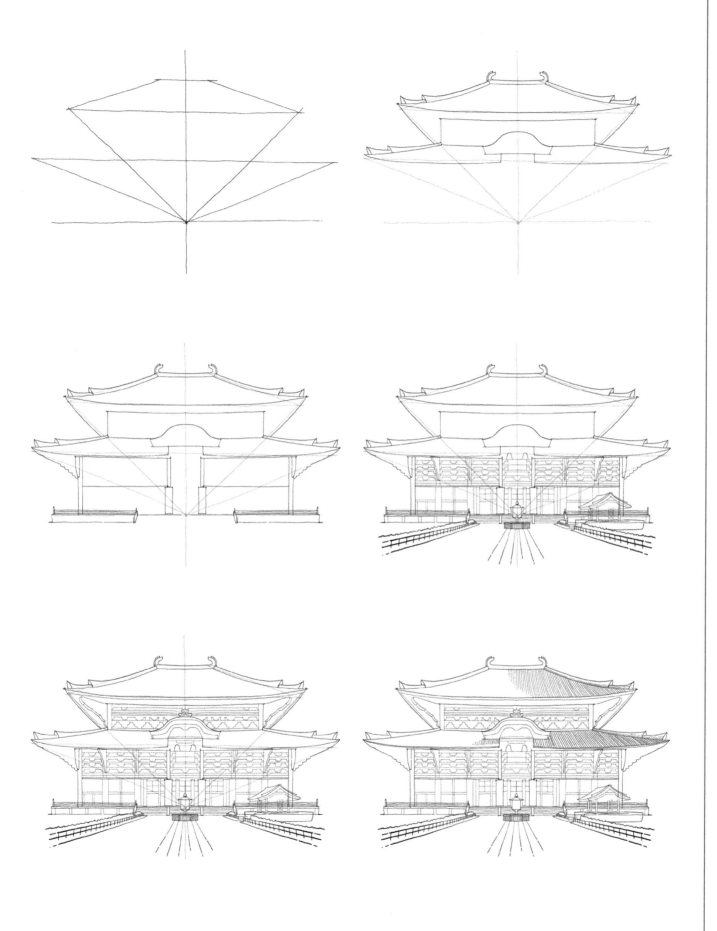

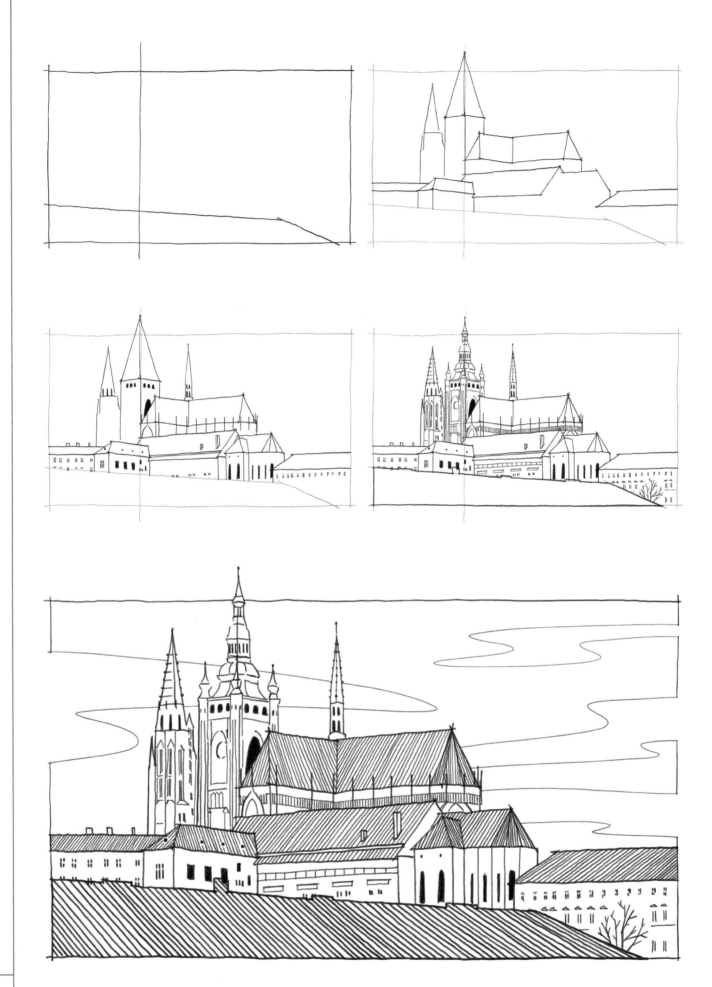

PRAGUE CASTLE / ATTRIBUTED TO MATTHIAS OF ARRAS, PETER PARLER | PRAGUE, CZECH REPUBLIC

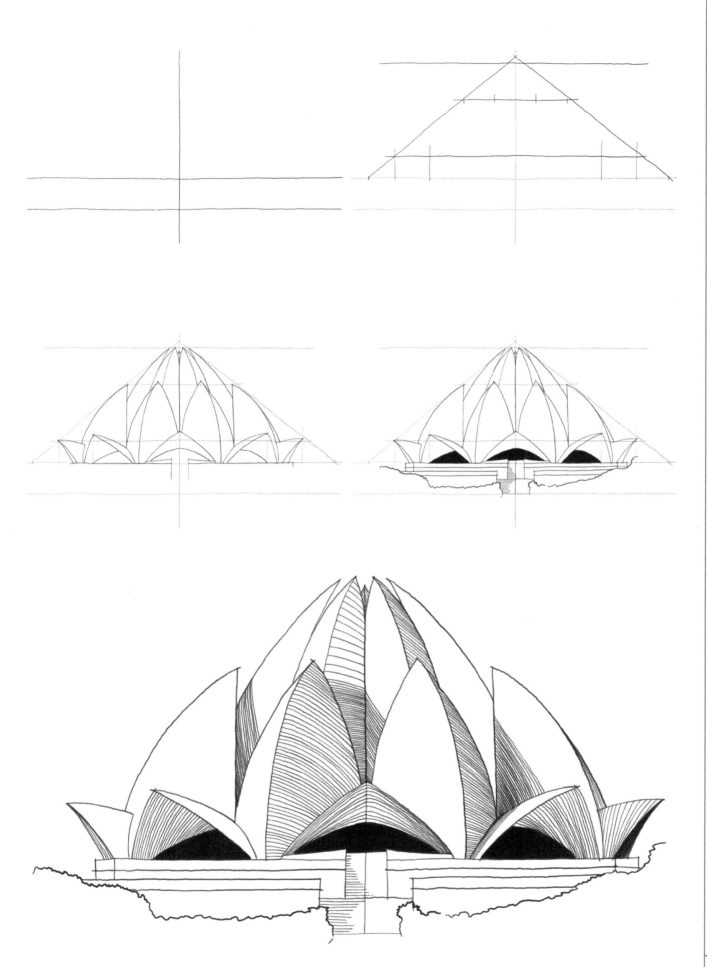

LOTUS TEMPLE / FARIBORZ SAHBA | DELHI, INDIA

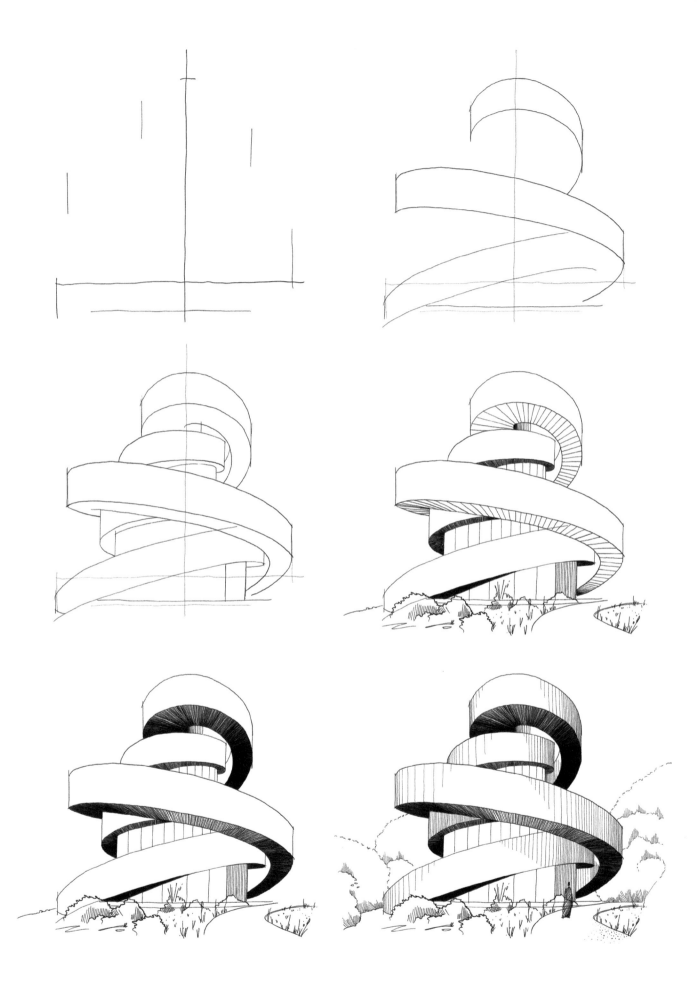

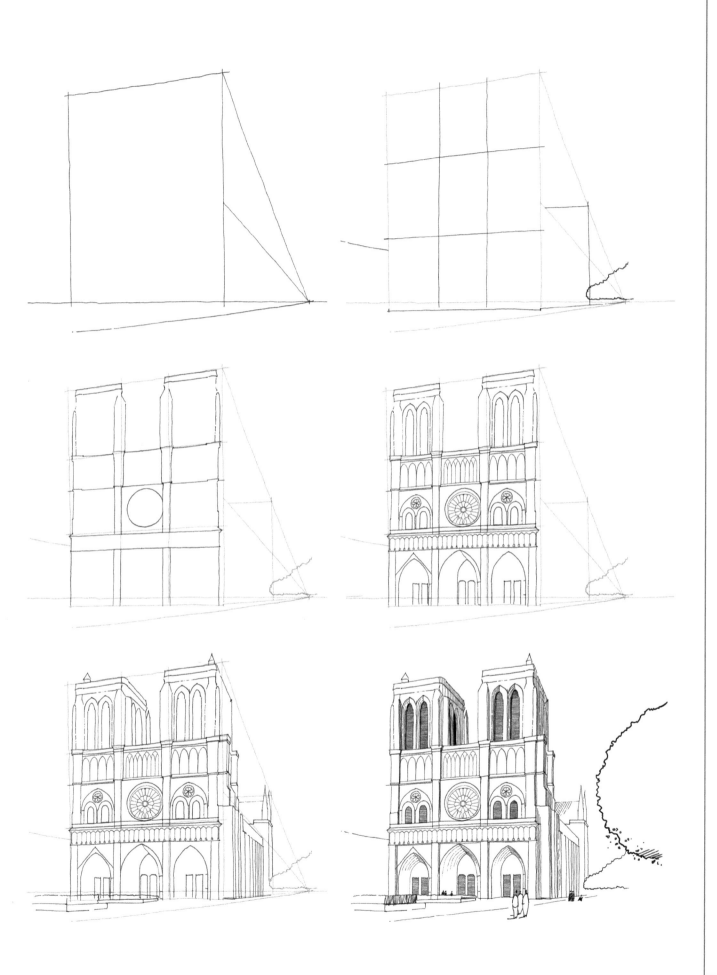

NOTRE-DAME DE PARIS | PARIS

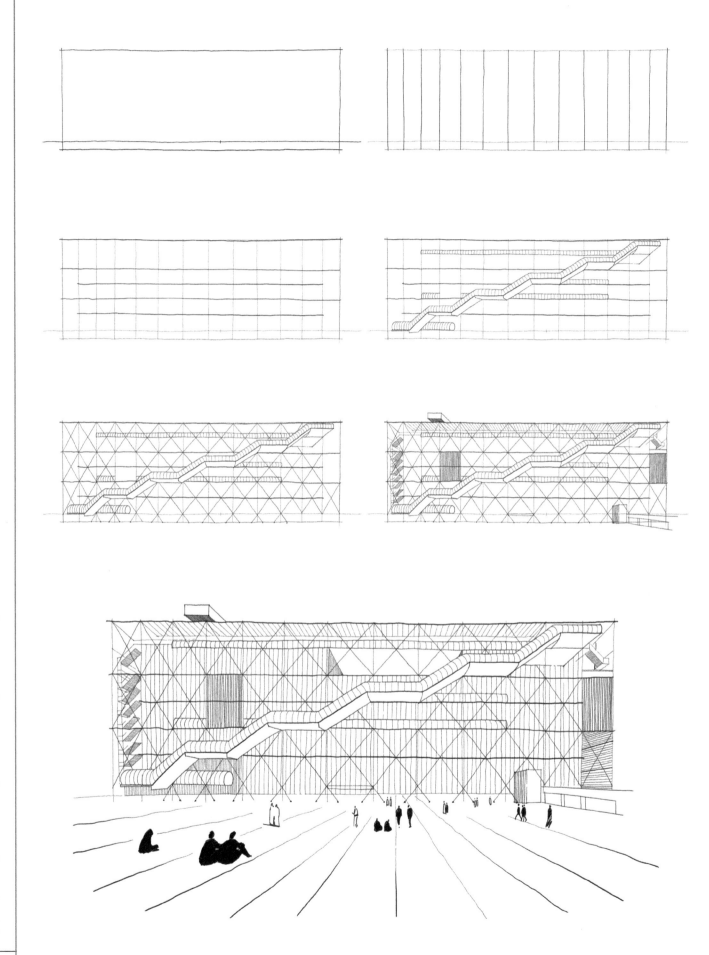

CENTRE GEORGES POMPIDOU / RENZO PIANO BUILDING WORKSHOP, RICHARD ROGERS | PARIS

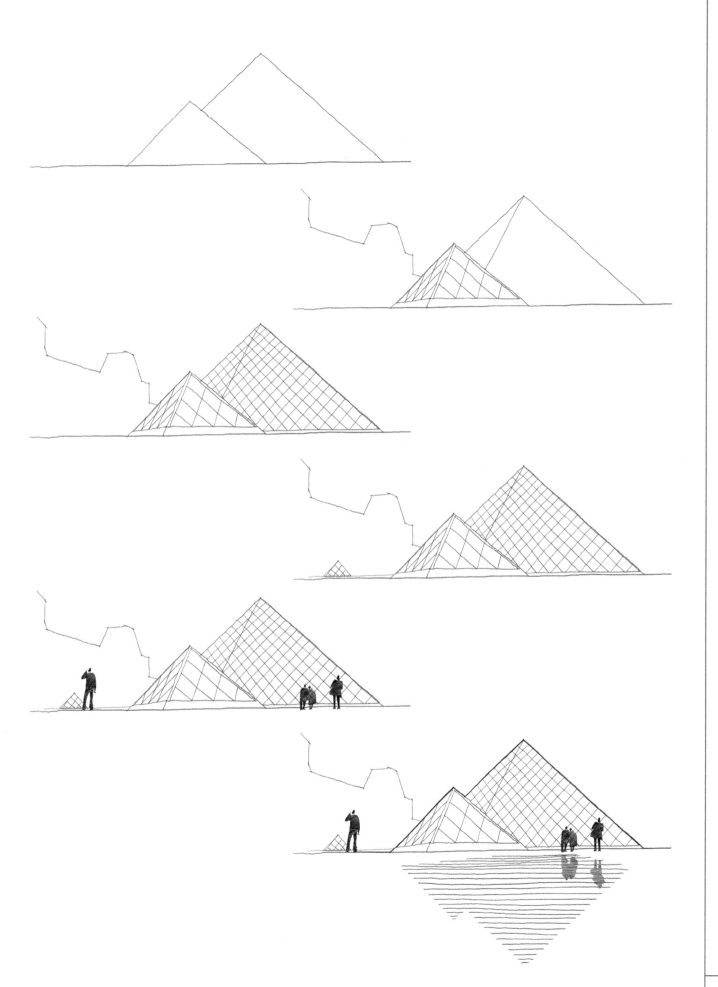

LOUVRE PYRAMID / I. M. PEI | PARIS

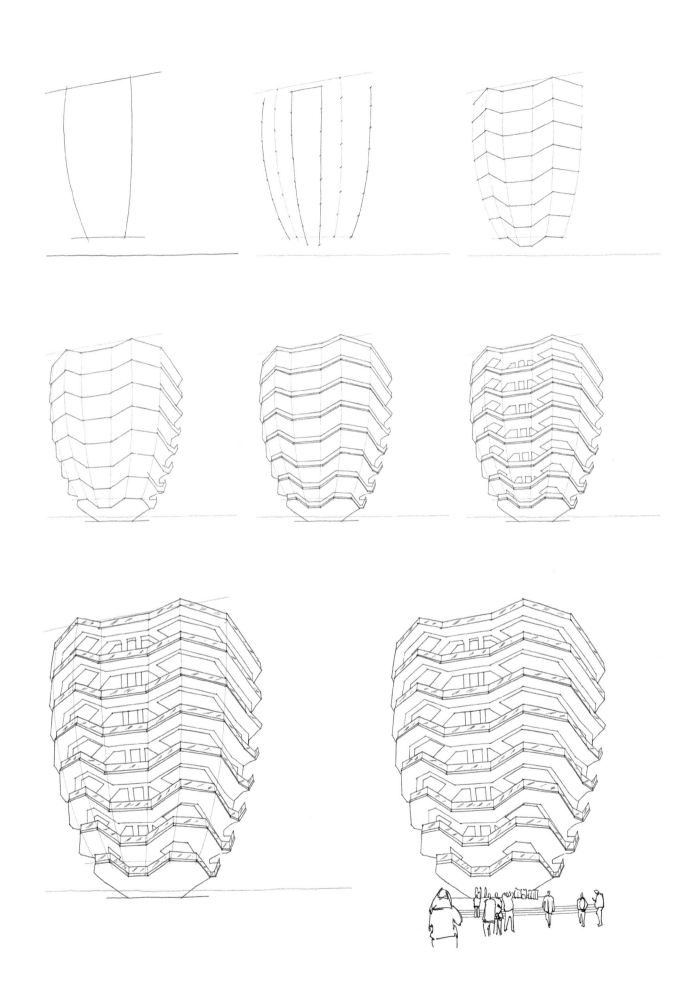

VESSEL / HEATHERWICK STUDIO | NEW YORK CITY

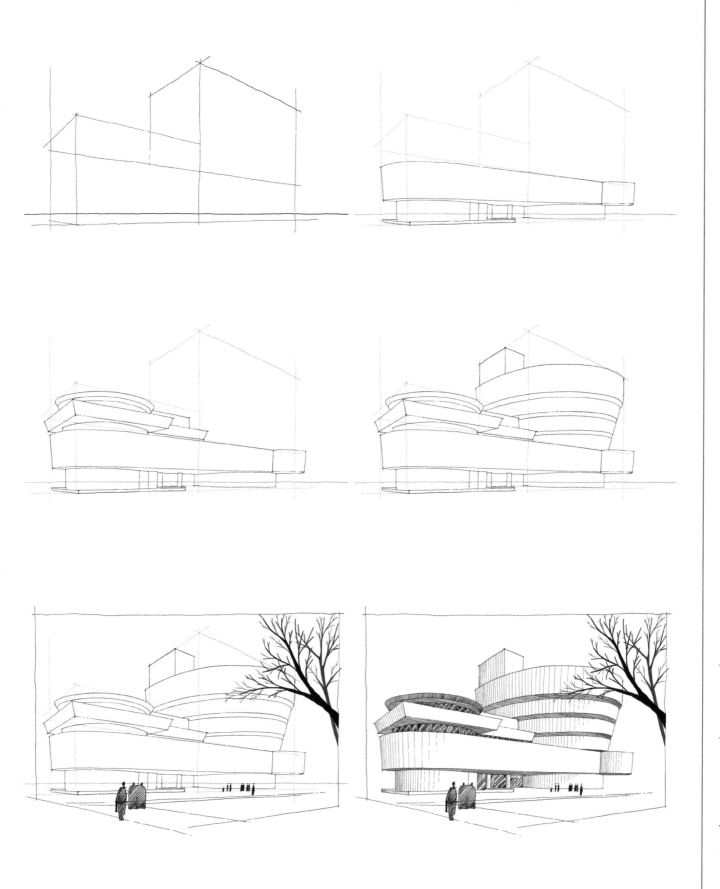

SOLOMON R. GUGGENHEIM MUSEUM / FRANK LLOYD WRIGHT | NEW YORK CITY

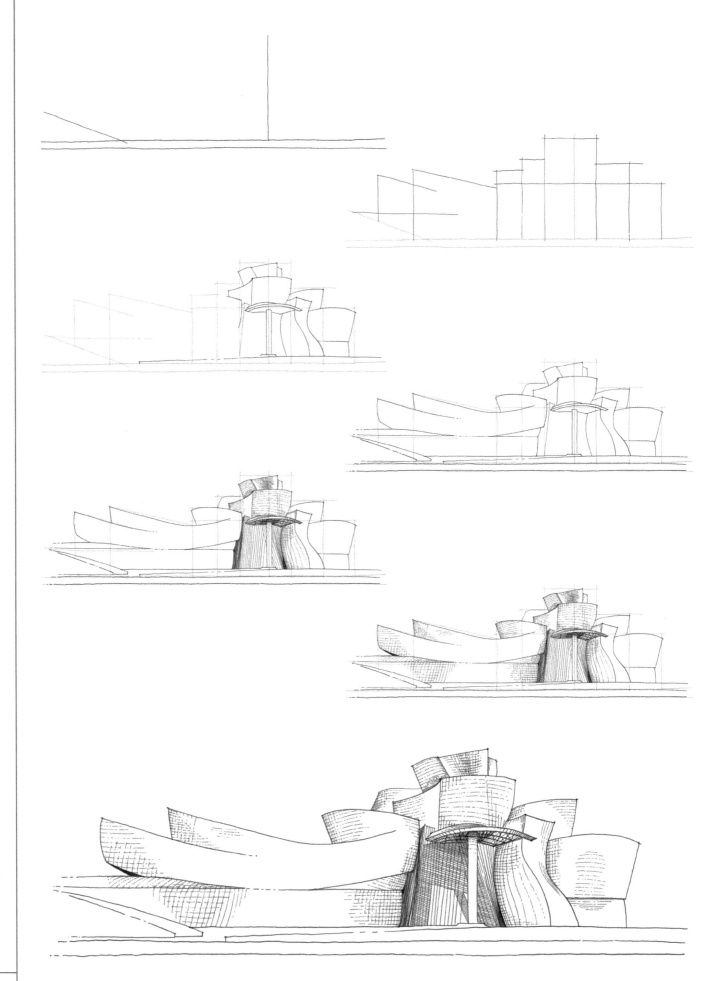

CULTURAL (MUSEUMS / GALLERIES / LIBRARIES)

GUGGENHEIM MUSEUM BILBAO / FRANK GEHRY | BILBAO, SPAIN

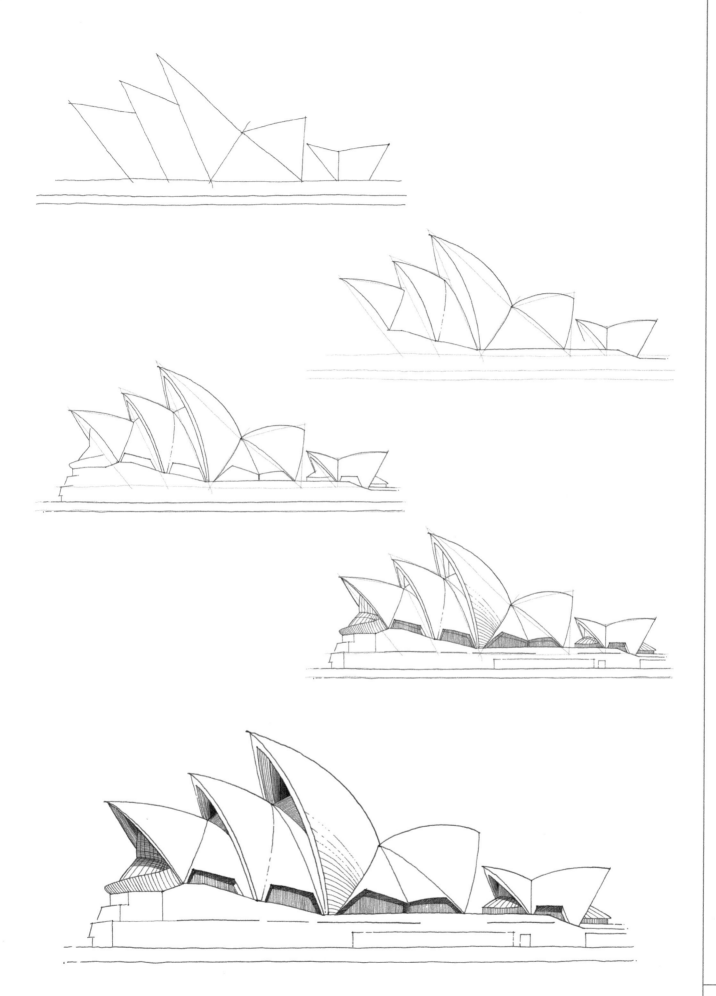

SYDNEY OPERA HOUSE / JØRN UTZON | SYDNEY, AUSTRALIA

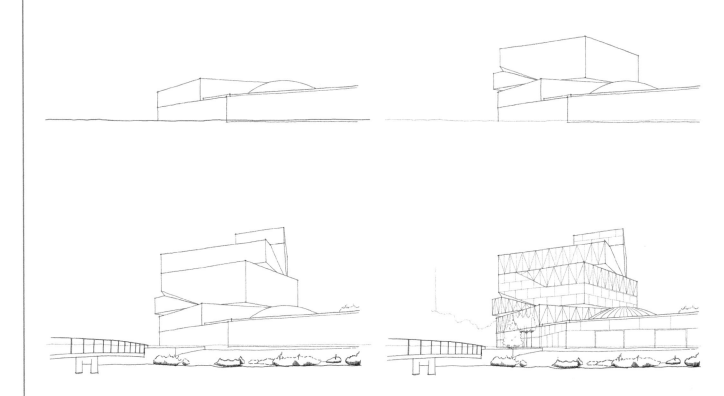

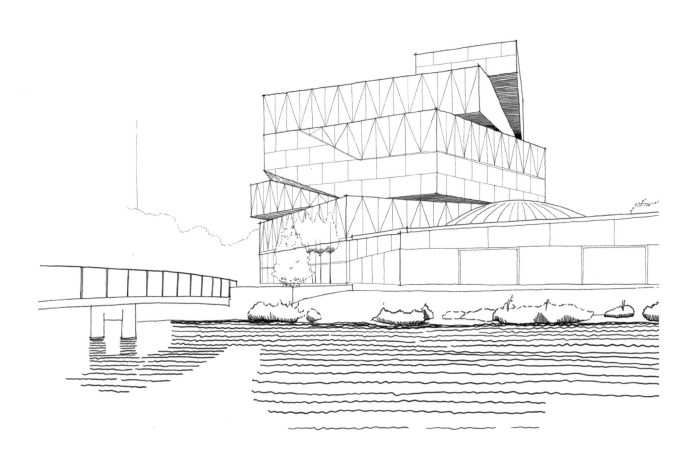

EXPERIMENTA BUILDING / SAUERBRUCH HUTTON | HEILBRONN, GERMANY

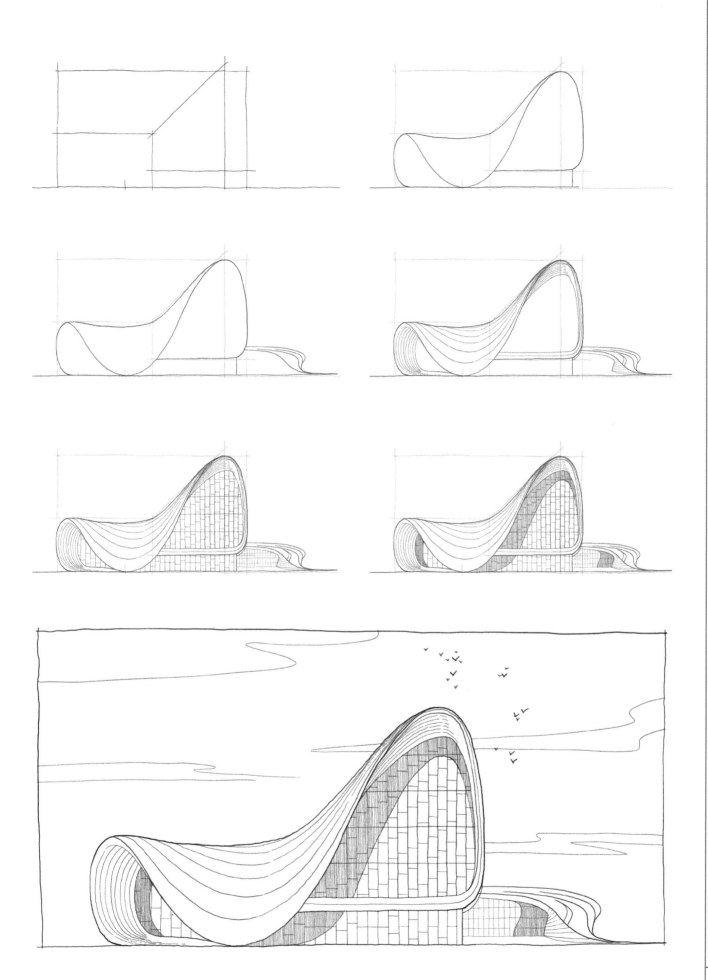

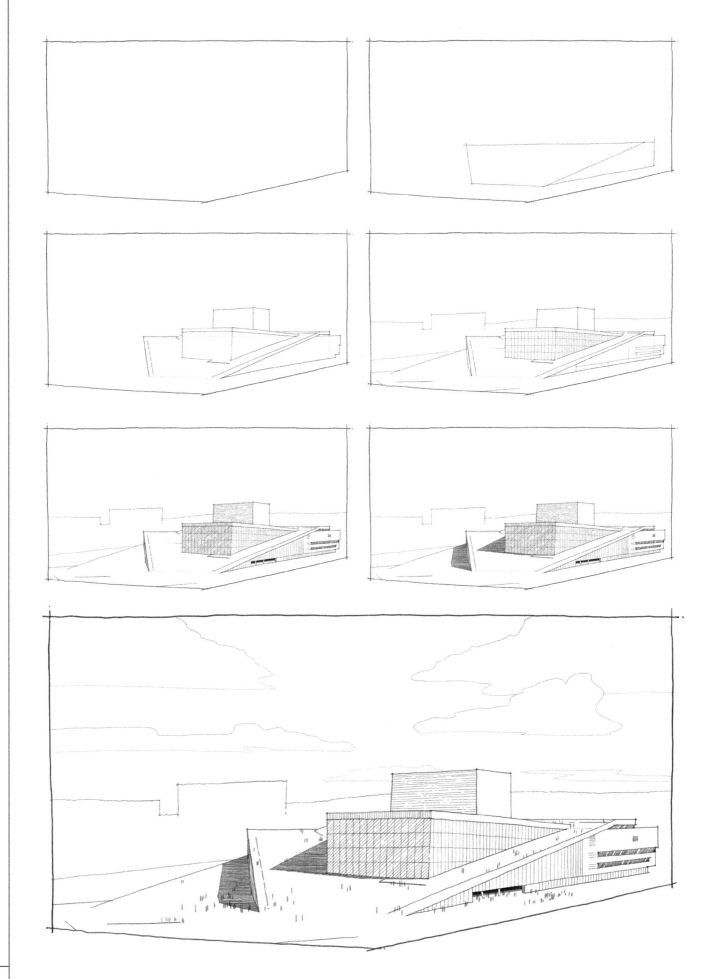

OSLO OPERA HOUSE / SNØHETTA | OSLO, NORWAY

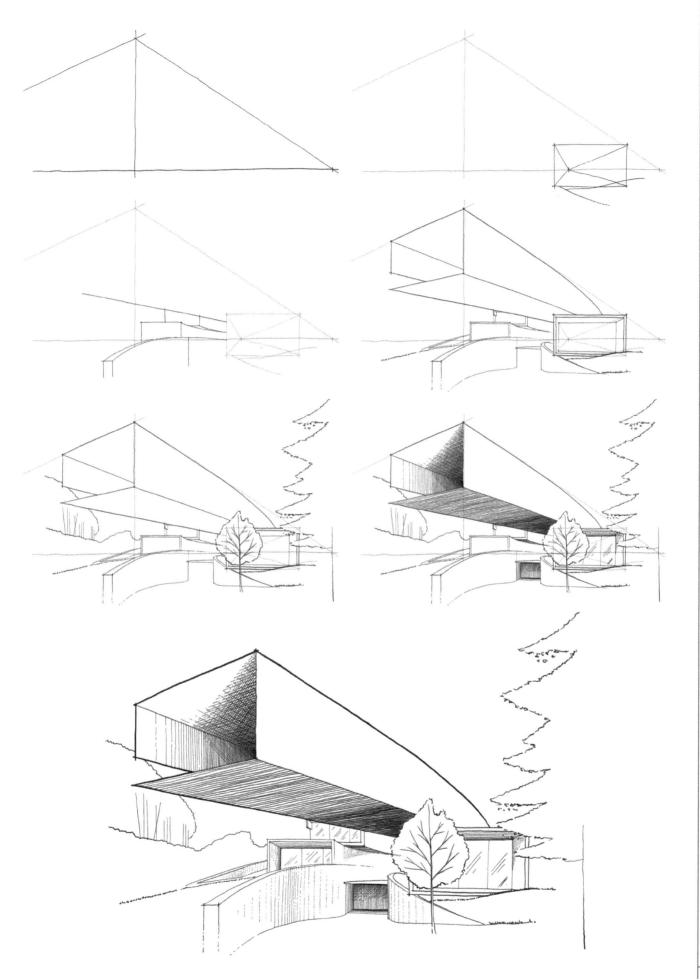

HOKI MUSEUM / NIKKEN SEKKEI | MIDORI-KU, CHIBA, JAPAN

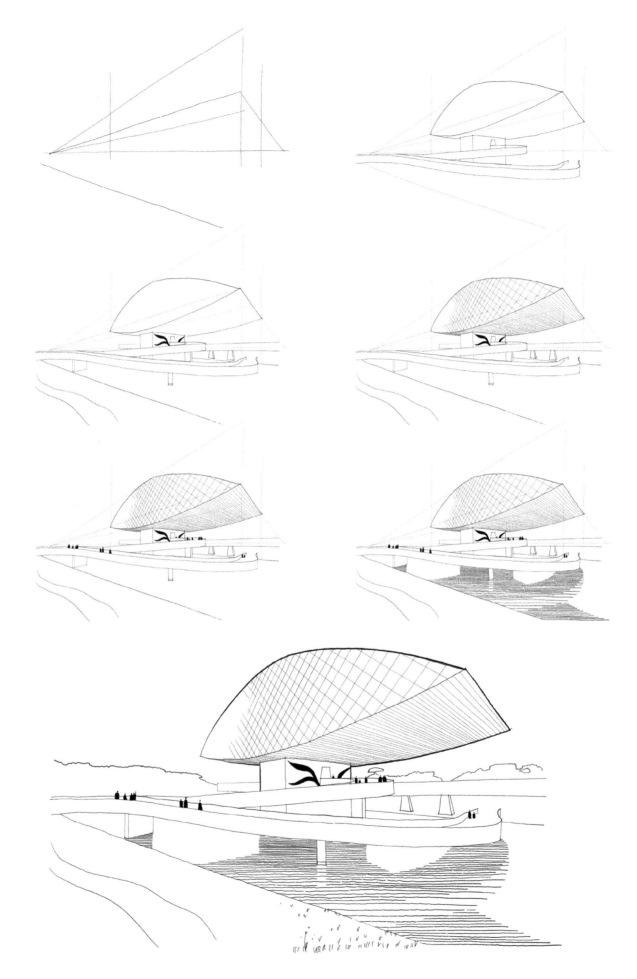

OSCAR NIEMEYER MUSEUM / OSCAR NIEMEYER | CURITIBA, BRAZIL

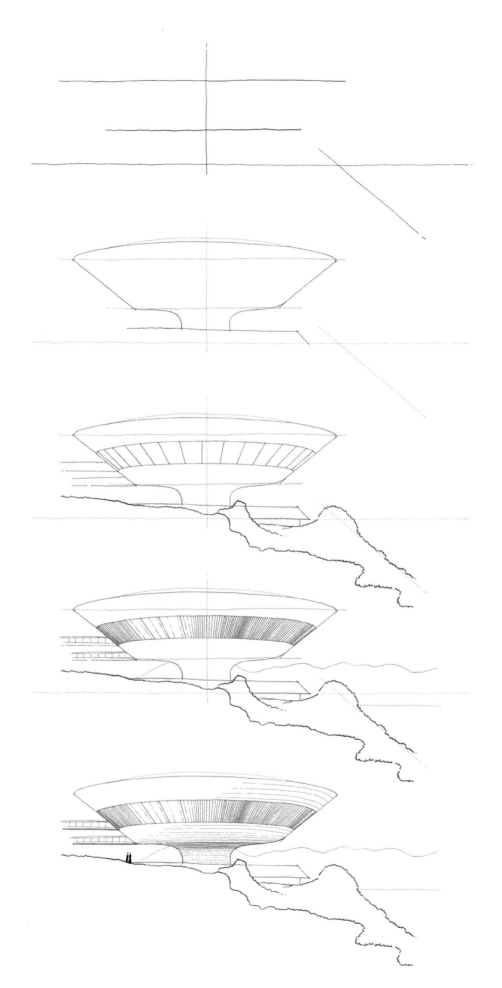

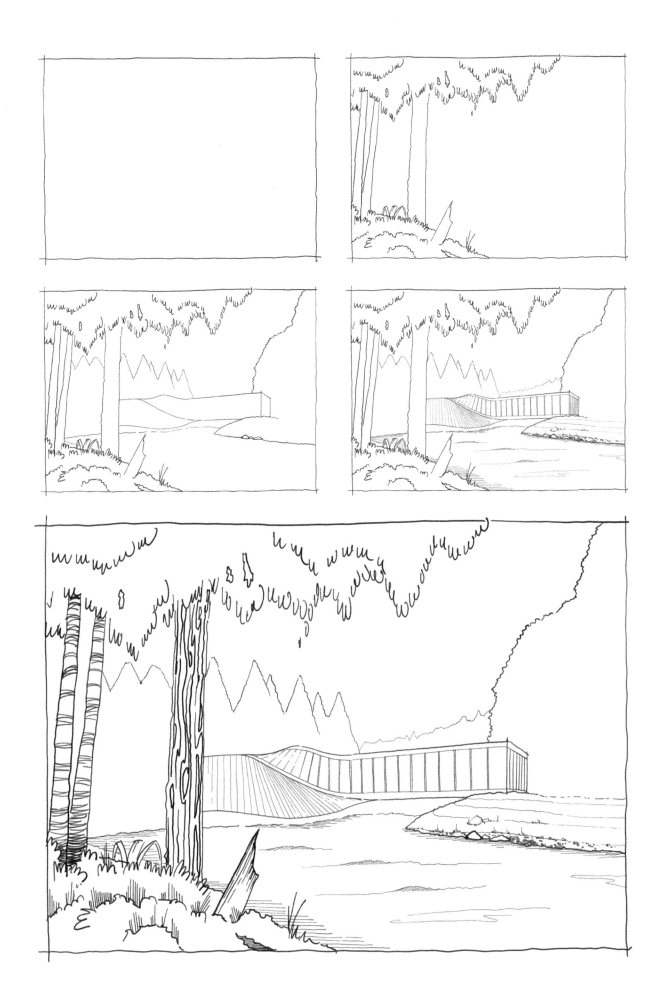

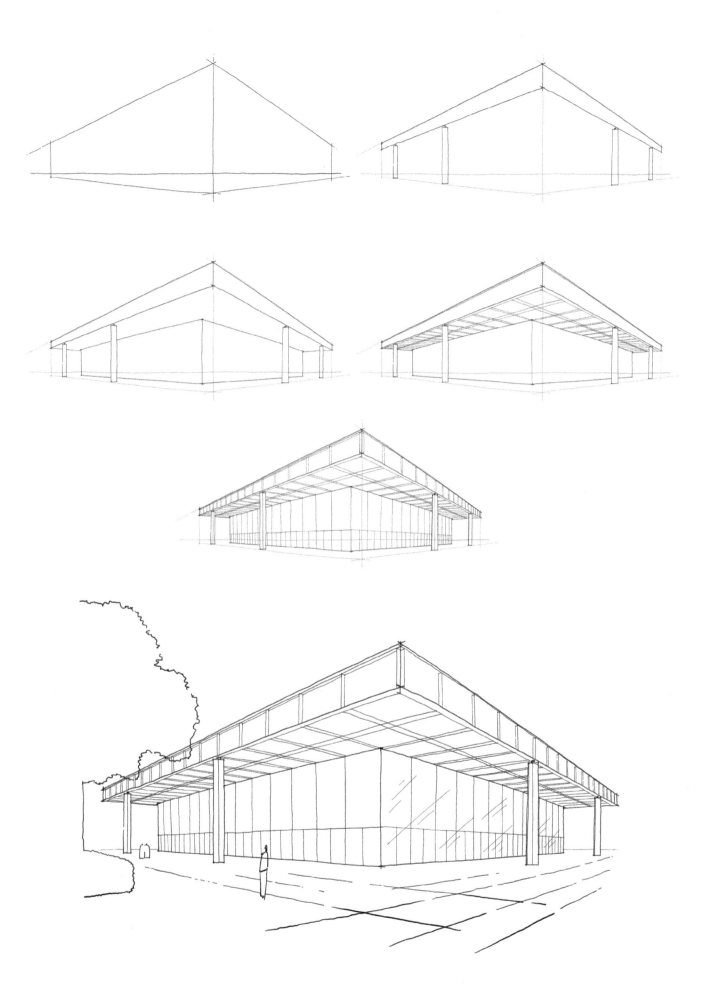

NEUE NATIONALGALERIE / LUDWIG MIES VAN DER ROHE | BERLIN

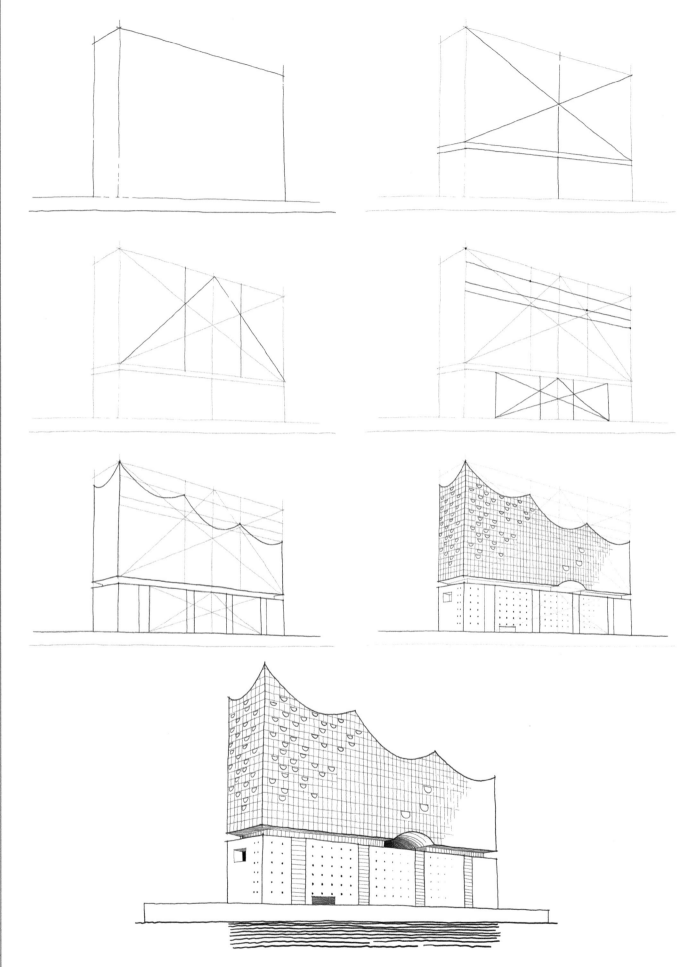

CULTURAL (MUSEUMS / GALLERIES / LIBRARIES)

ELBPHILHARMONIE / HERZOG & DE MEURON | HAMBURG, GERMANY

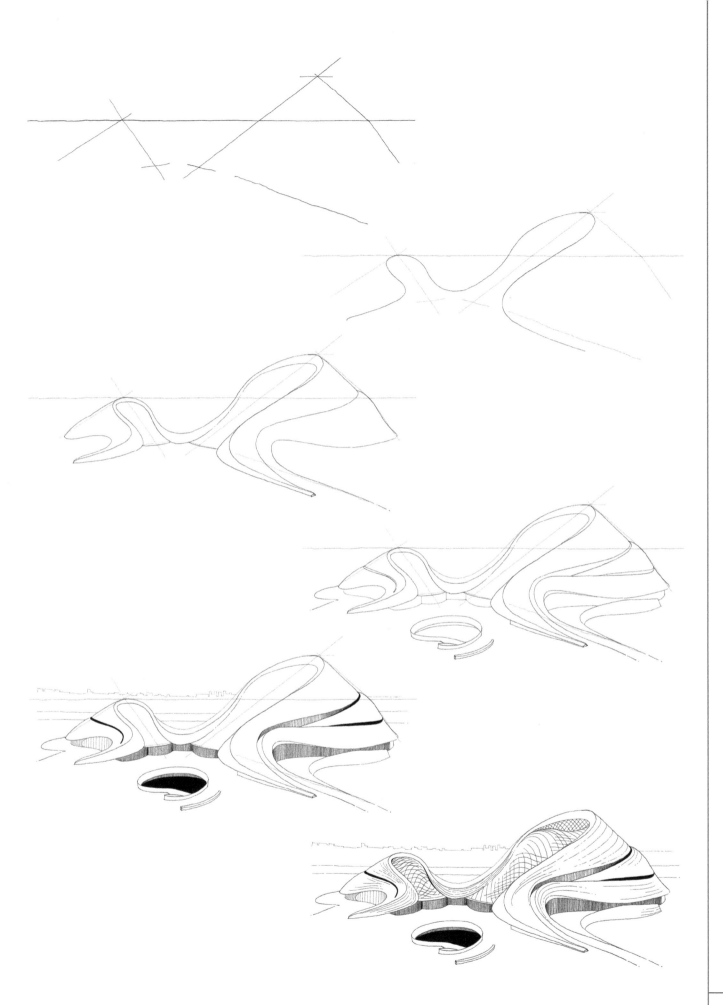

HARBIN OPERA HOUSE / MAD ARCHITECTS | HARBIN, CHINA

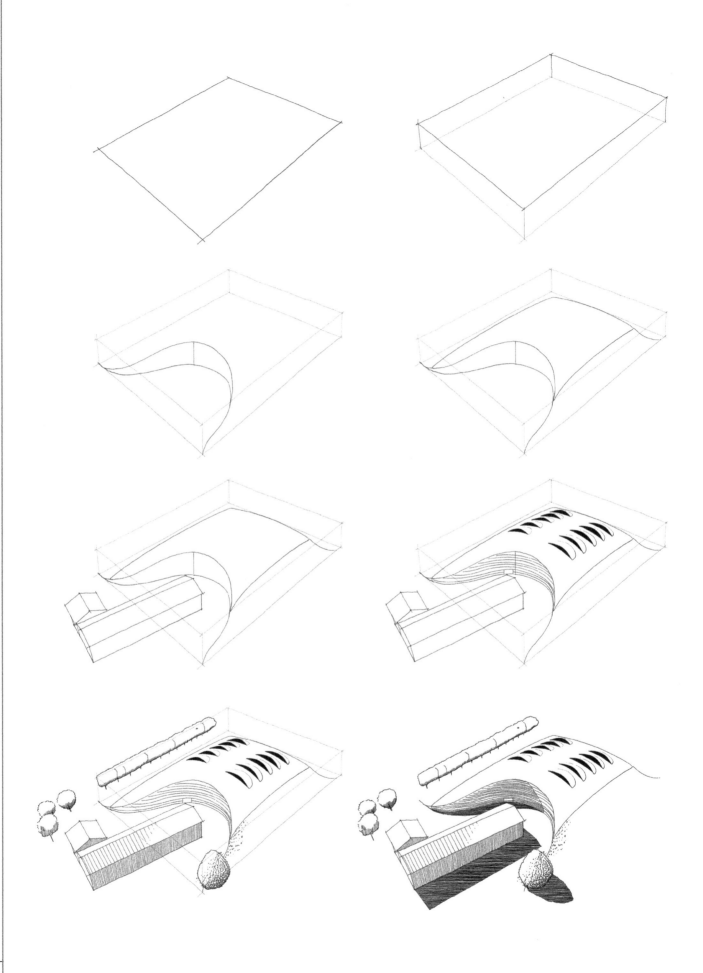

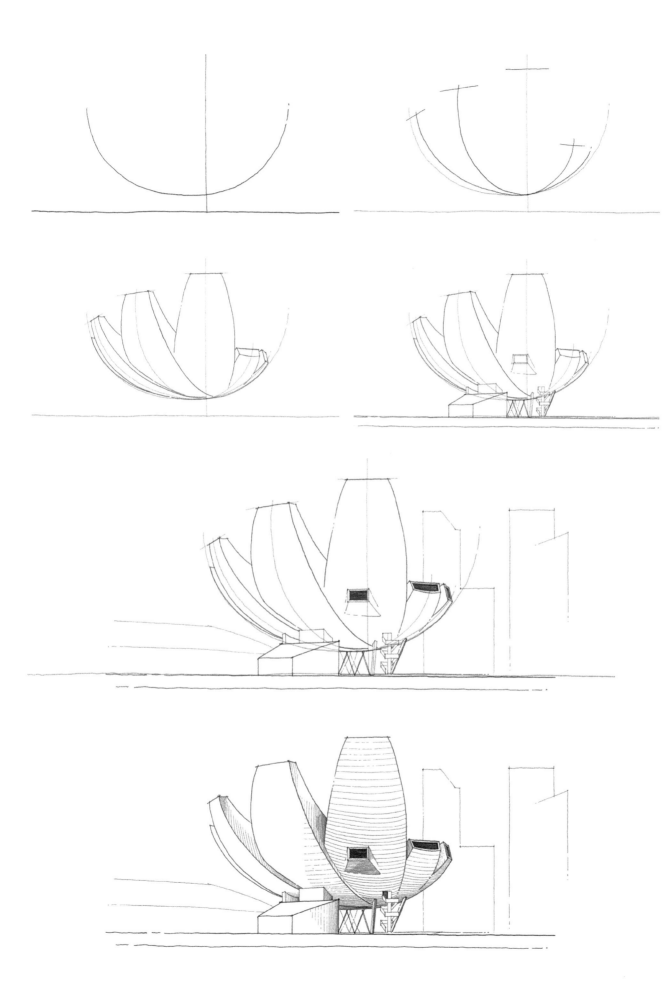

ARTSCIENCE MUSEUM / SAFDIE ARCHITECTS | SINGAPORE

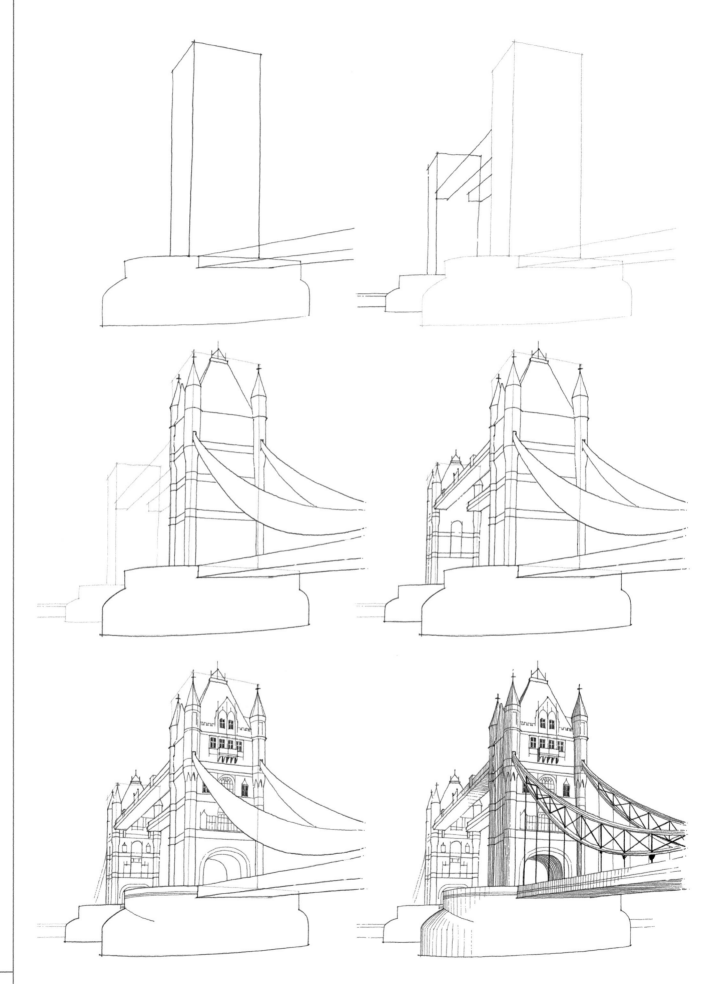

TOWER BRIDGE / ATTRIBUTED TO HORACE JONES | LONDON

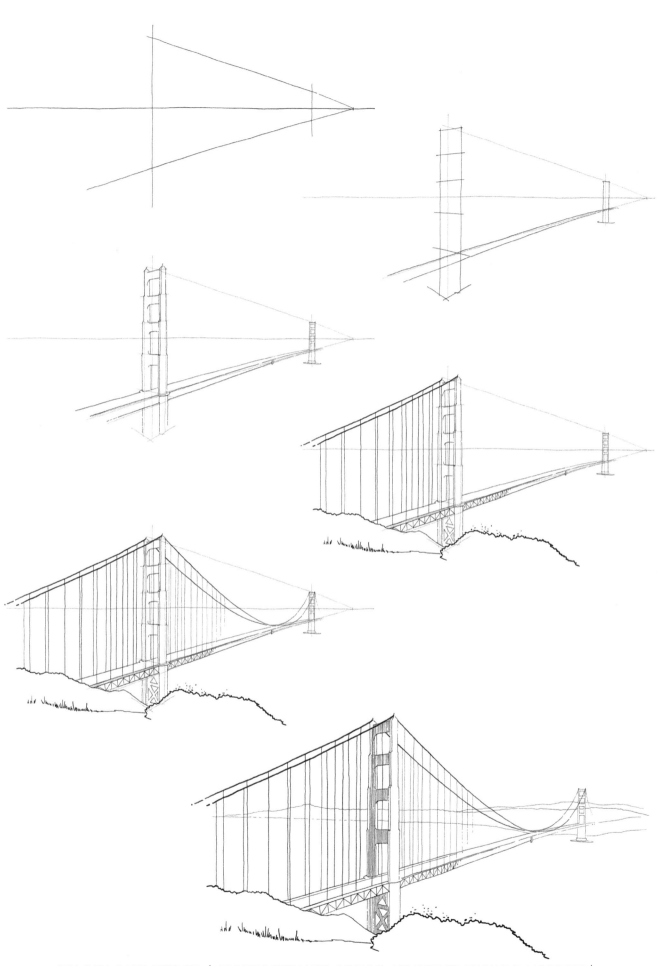

GOLDEN GATE BRIDGE / JOSEPH STRAUSS, LEON S. MOISSEIFF, IRVING F. MORROW |
SAN FRANCISCO, CALIFORNIA, USA

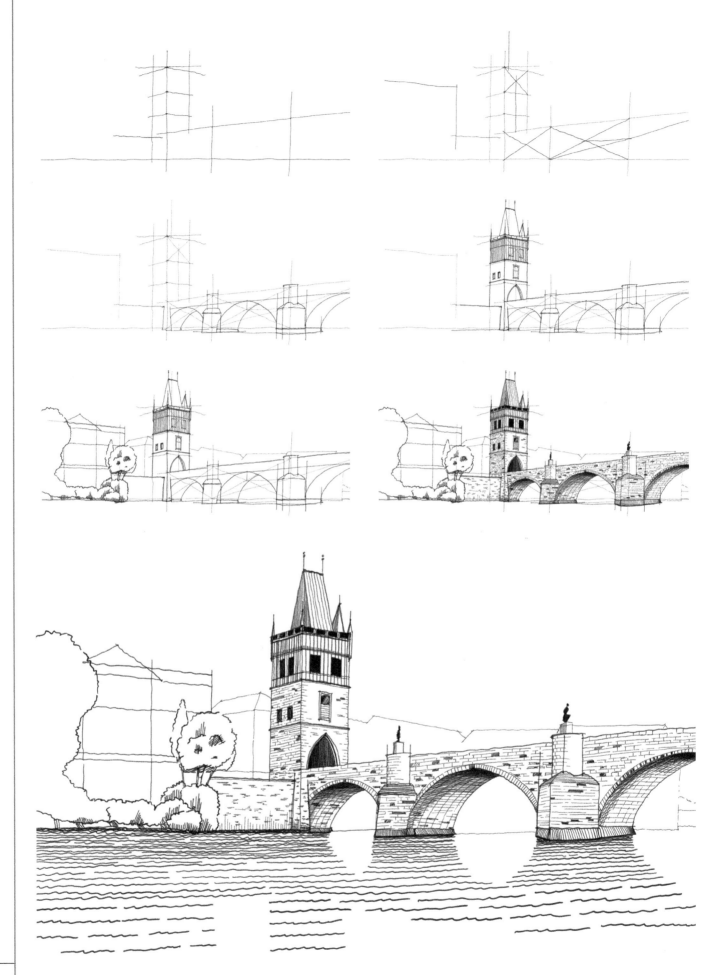

CHARLES BRIDGE / ATTRIBUTED TO PETER PARLER | PRAGUE, CZECH REPUBLIC

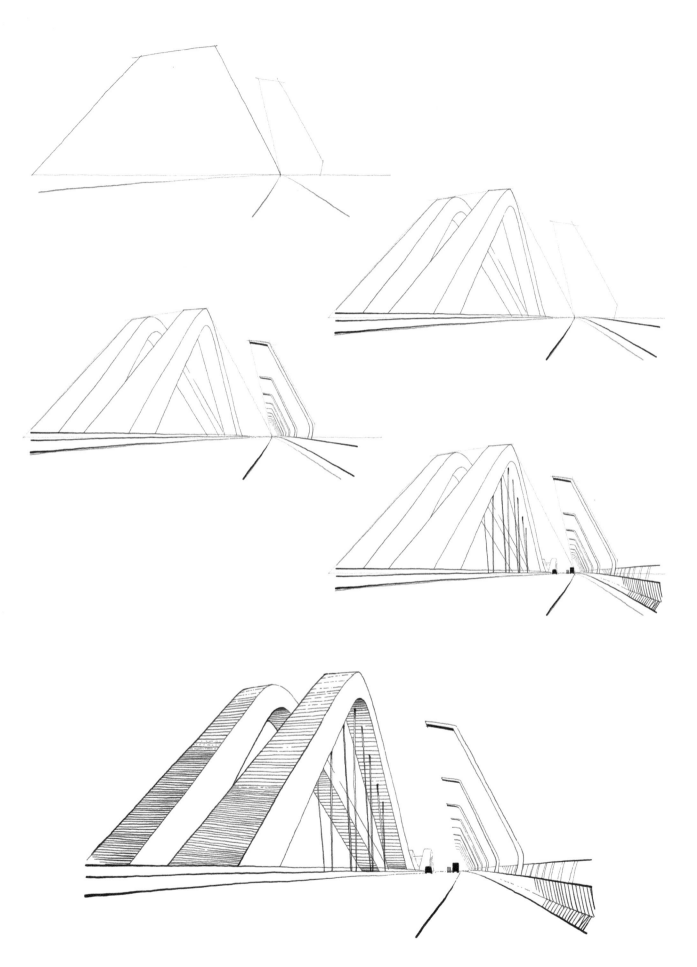

SHEIKH ZAYED BRIDGE / ZAHA HADID ARCHITECTS | ABU DHABI, UNITED ARAB EMIRATES

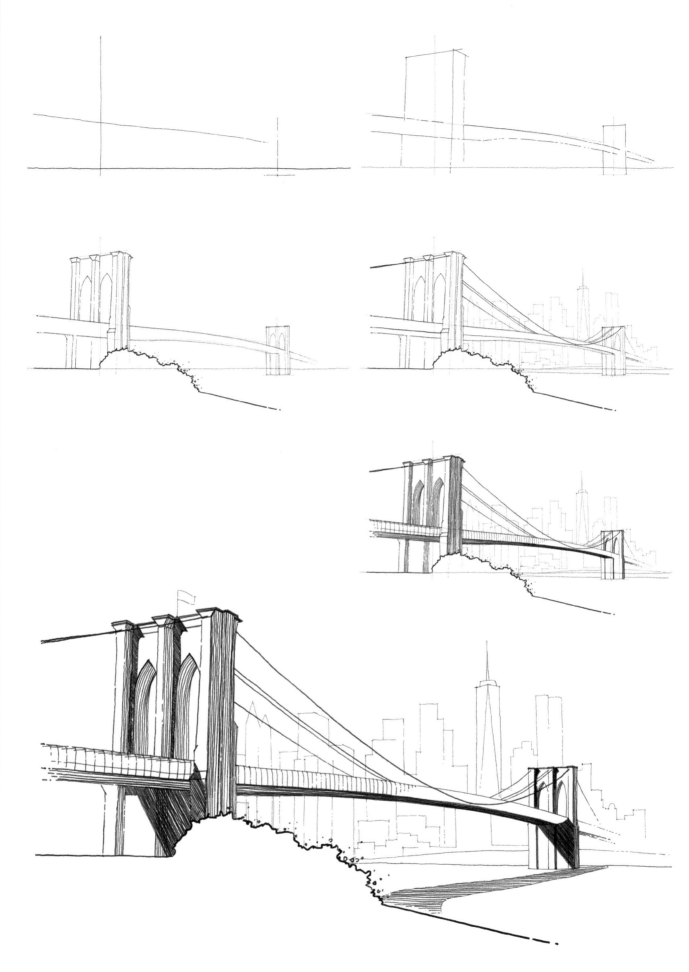

BROOKLYN BRIDGE / JOHN AUGUSTUS ROEBLING | NEW YORK CITY

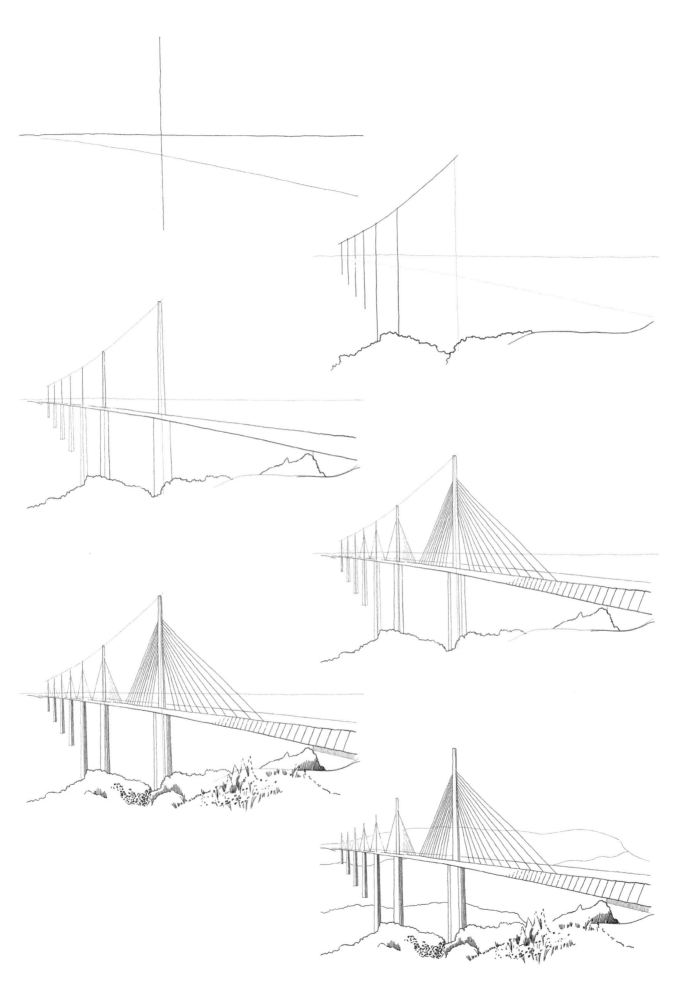

MILLAU VIADUCT / MICHEL VIRLOGEUX, NORMAN FOSTER | MILLAU, FRANCE

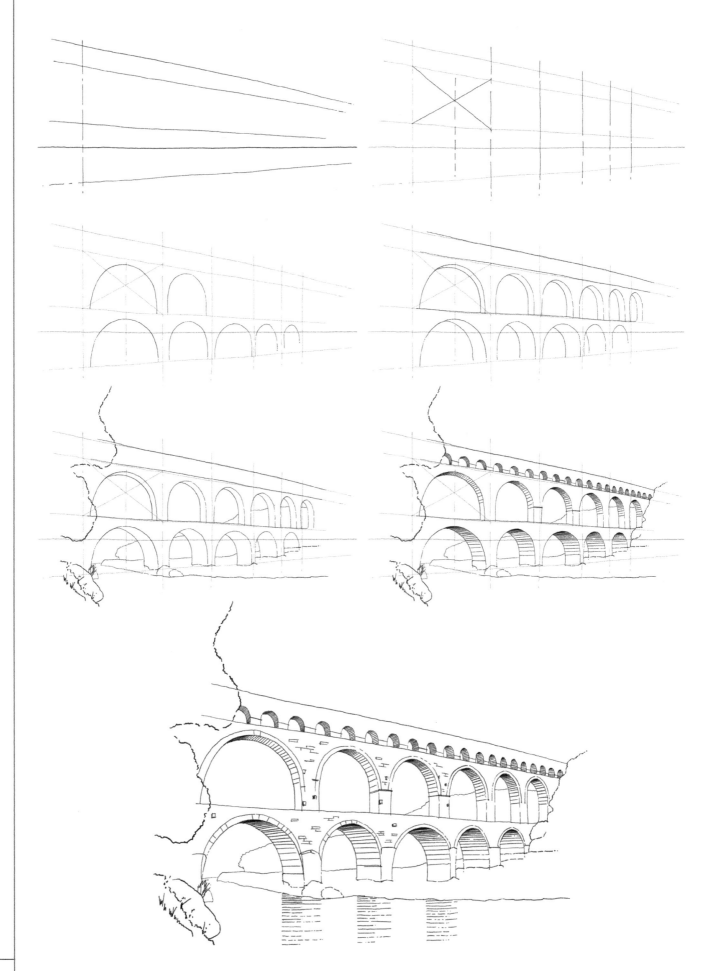

PONT DU GARD | VERS-PONT-DU-GARD, FRANCE

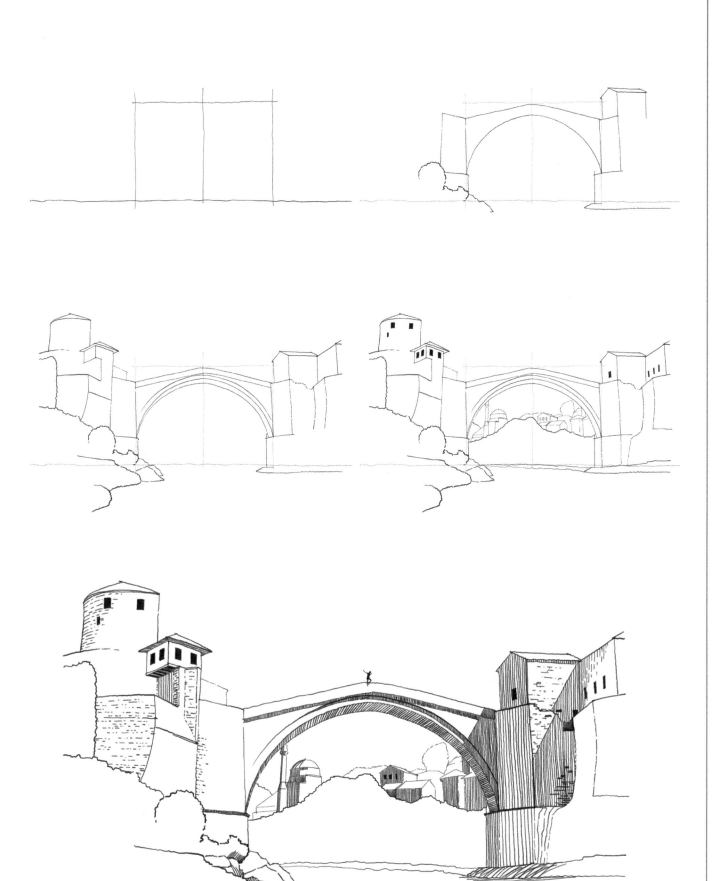

STARI MOST | MOSTAR, BOSNIA AND HERZEGOVINA

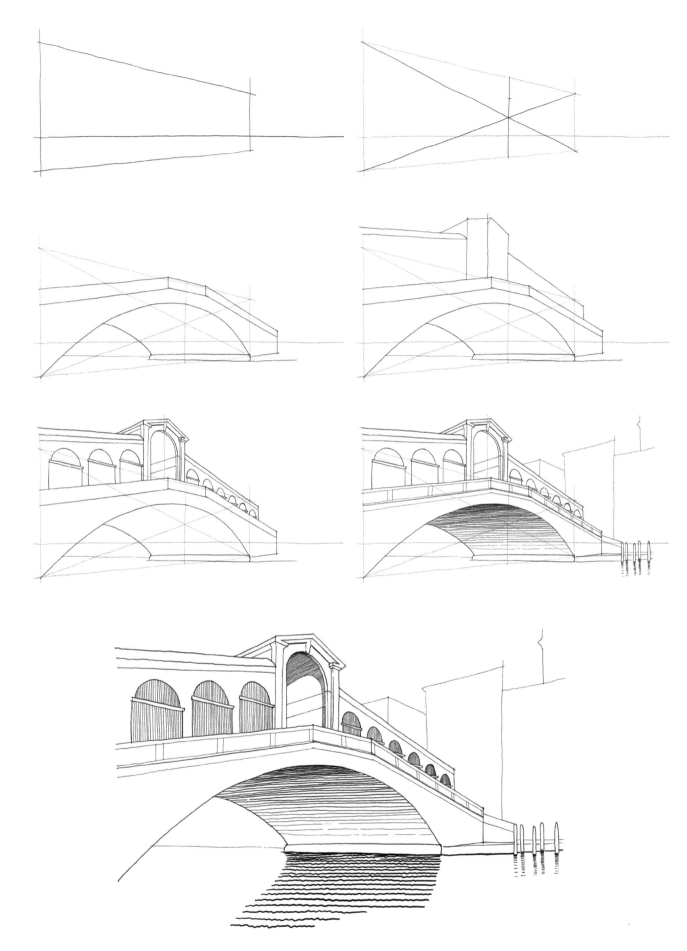

RIALTO BRIDGE / ATTRIBUTED TO NICOLÒ BARATTIERI | VENICE, ITALY

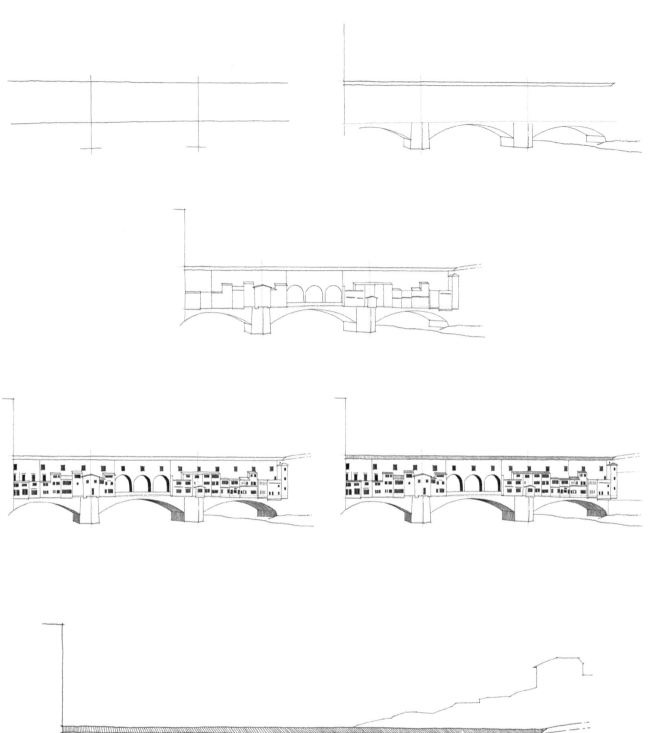

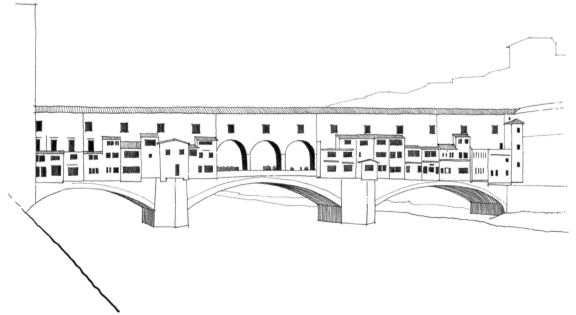

PONTE VECCHIO / ATTRIBUTED TO TADDEO GADDI, NERI DI FIORAVANTE | FLORENCE, ITALY

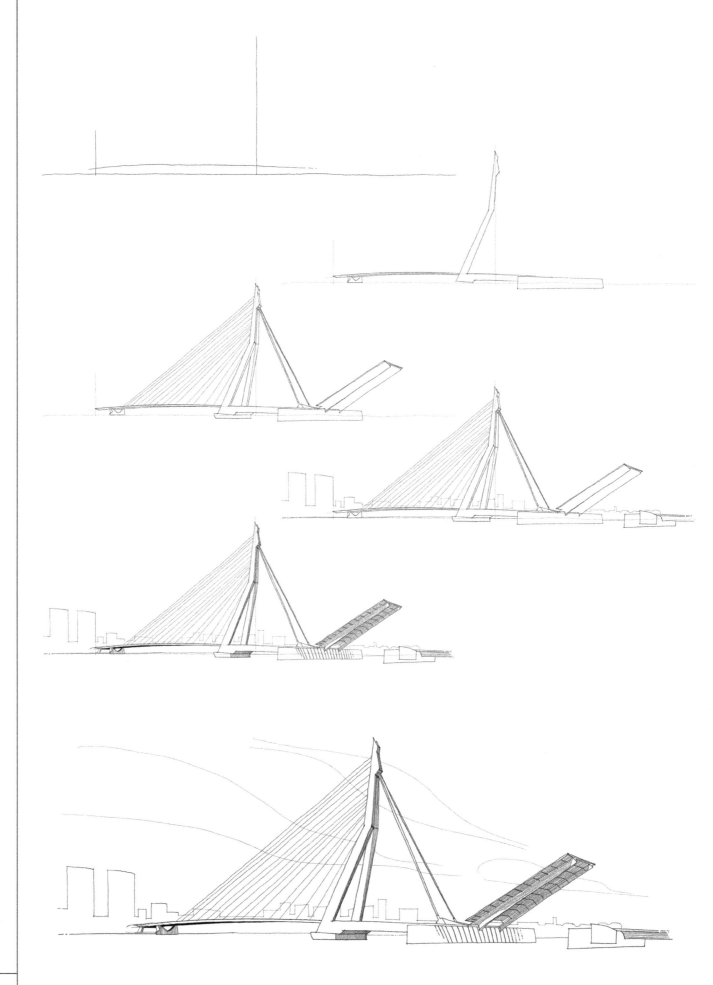

ERASMUS BRIDGE / BEN VAN BERKEL | ROTTERDAM, NETHERLANDS

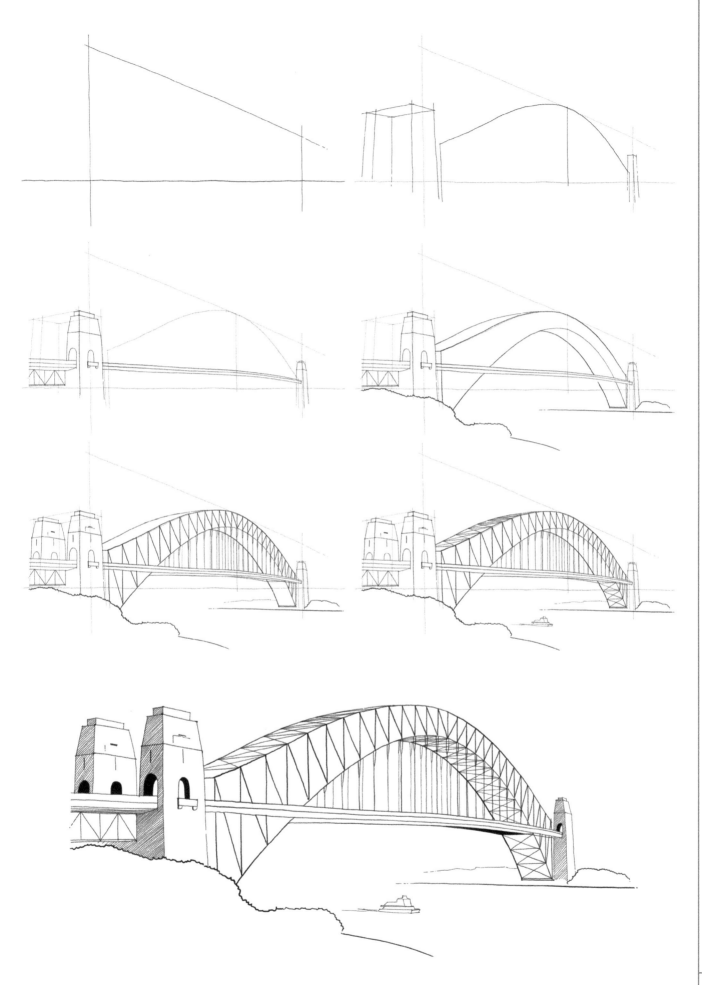

SYDNEY HARBOUR BRIDGE / DORMAN LONG | SYDNEY, AUSTRALIA

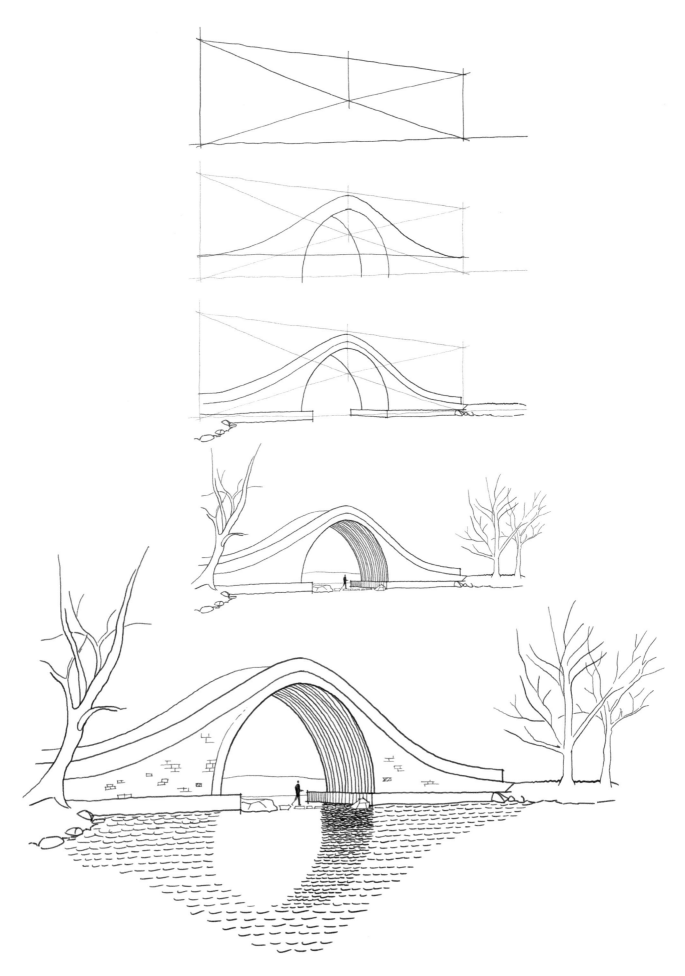

JADE BELT BRIDGE | BEIJING

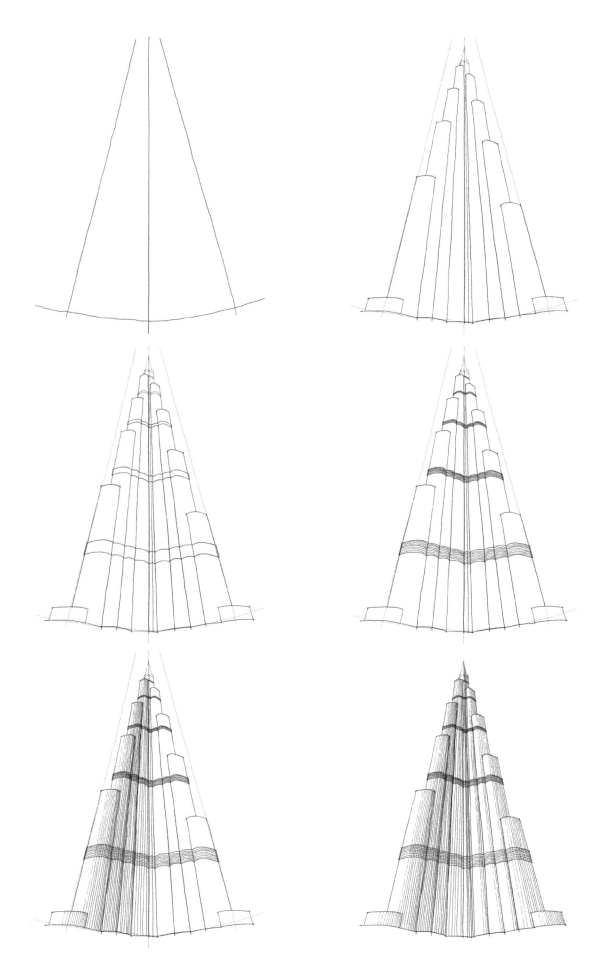

BURJ KHALIFA / SKIDMORE, OWINGS & MERRILL | DUBAI, UNITED ARAB EMIRATES

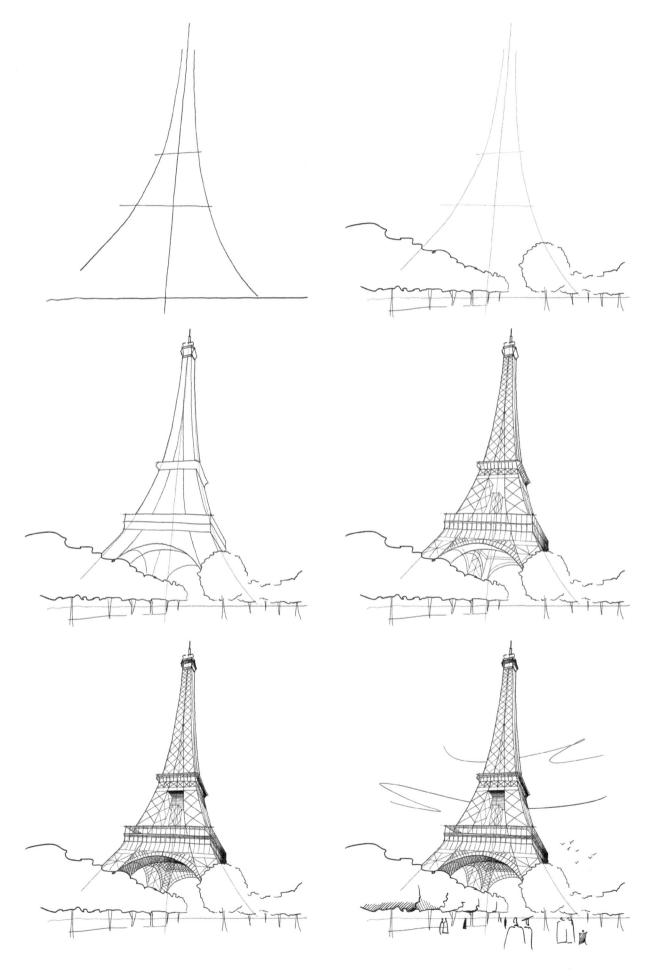

TOWERS / HIGH-RISES / SKYSCRAPERS

EIFFEL TOWER / MAURICE KOECHLIN, ÉMILE NOUGUIER, STEPHEN SAUVESTRE | PARIS

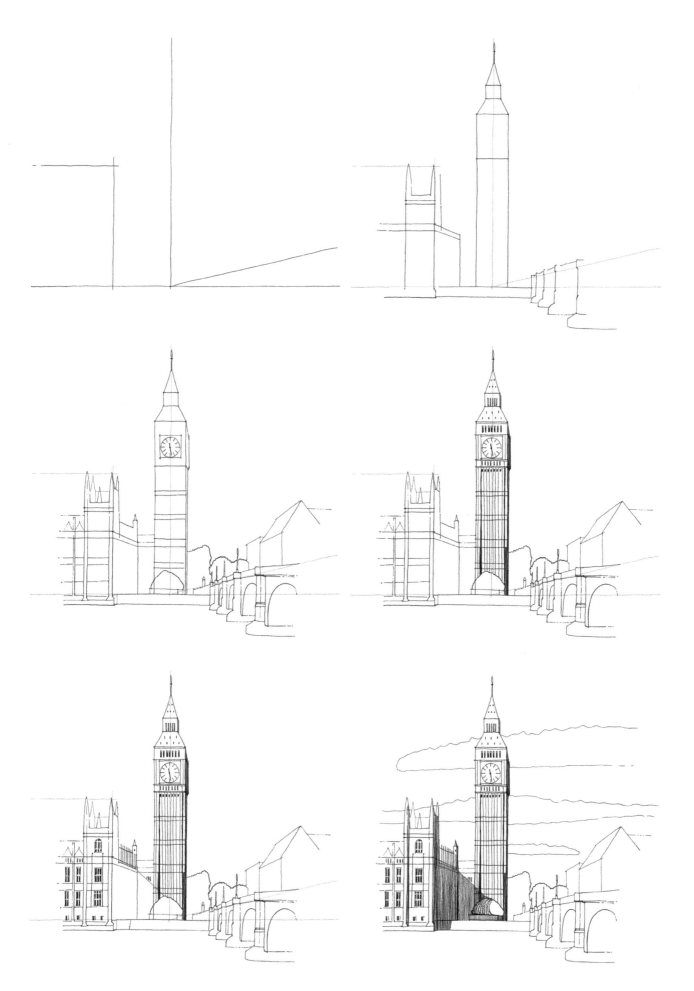

BIG BEN / AUGUSTUS PUGIN | LONDON

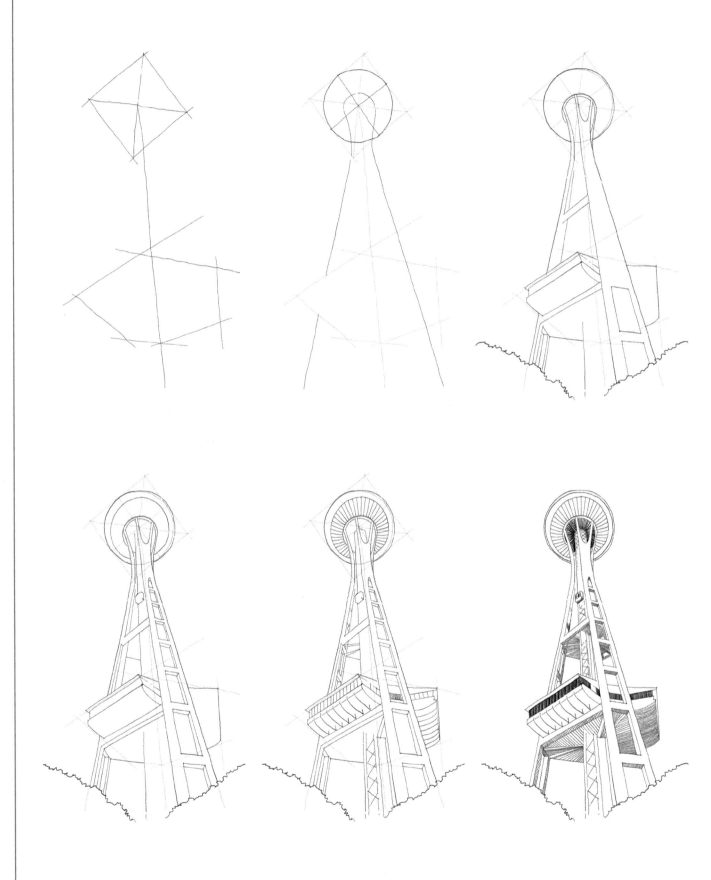

SPACE NEEDLE / JOHN GRAHAM & COMPANY | SEATTLE, WASHINGTON, USA

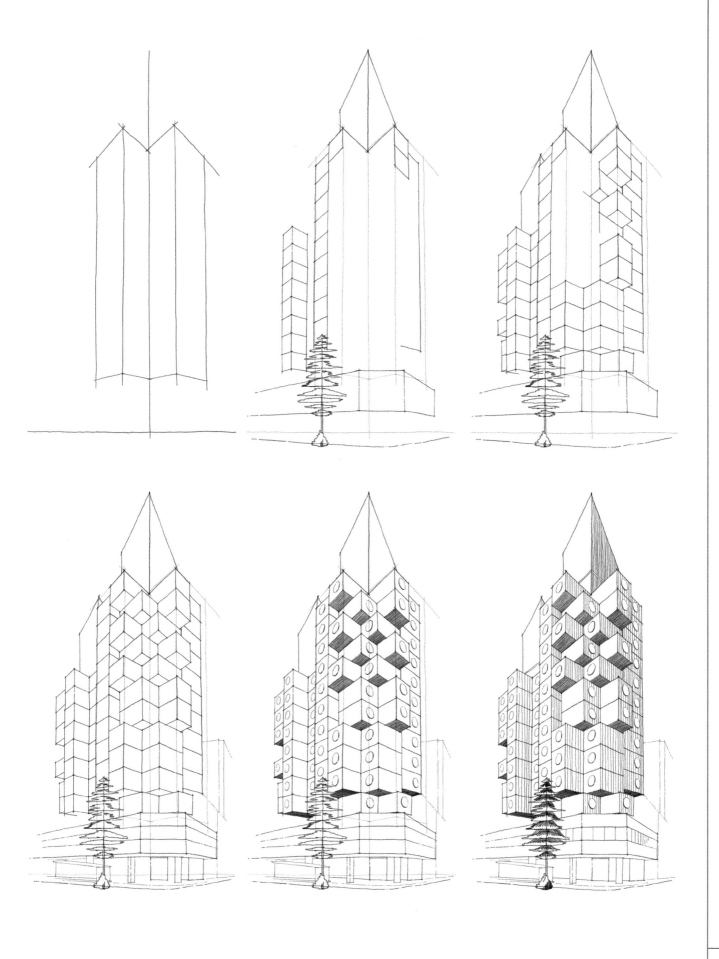

NAKAGIN CAPSULE TOWER / KISHO KUROKAWA | TOKYO, JAPAN

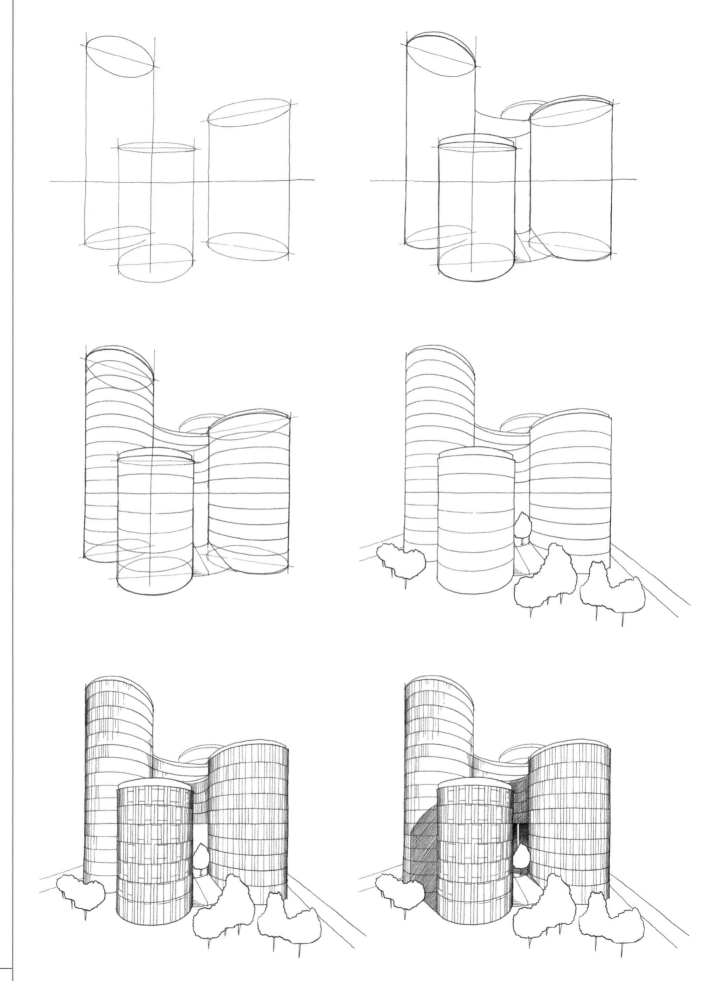

AXEL TOWERS / LUNDGAARD & TRANBERG | COPENHAGEN, DENMARK

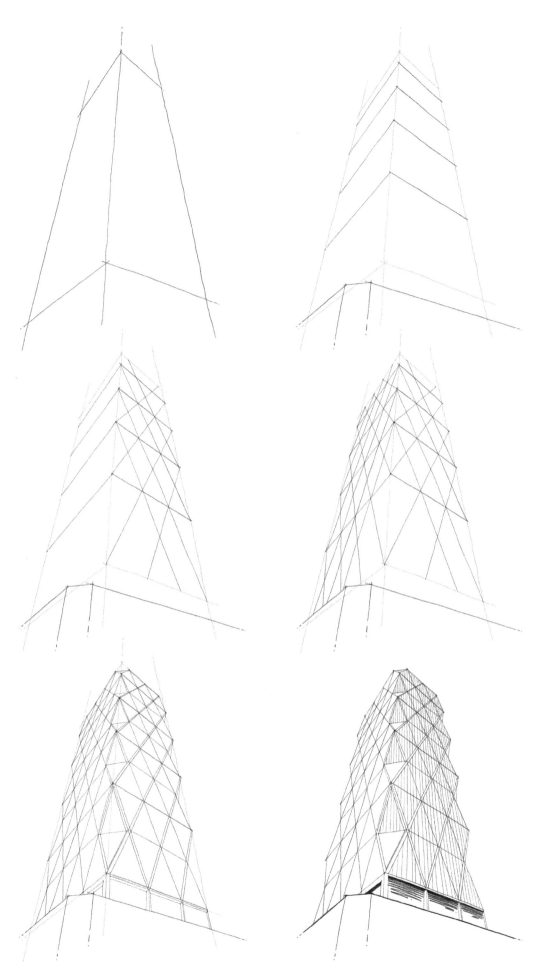

HEARST TOWER / FOSTER + PARTNERS | NEW YORK CITY

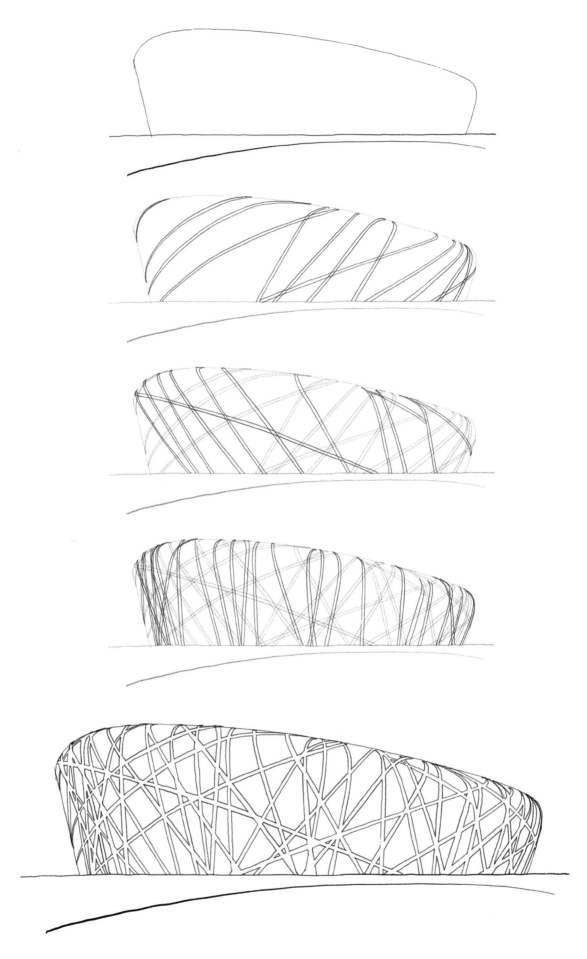

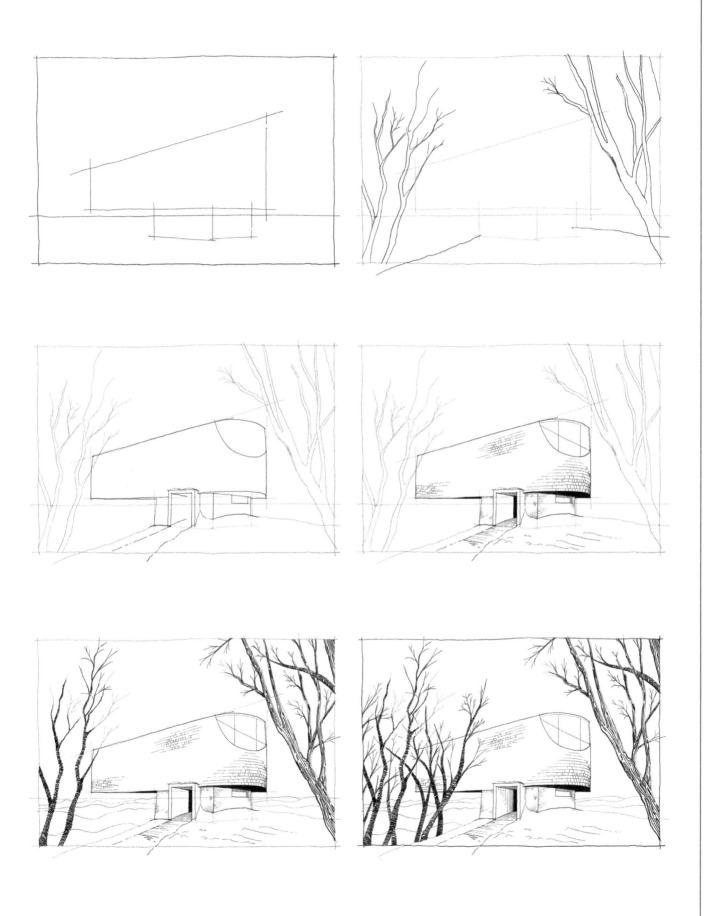

STAGE OF FOREST / META-PROJECT | JILIN, CHINA

ACKNOWLEDGMENTS

Creating this book was my first experience with traditional publishing, and thanks to the people mentioned below, it was a wonderful one! I didn't expect it to be easy—and it wasn't. There was lots to learn in the process. I'd love to give my thanks to these amazing people who were absolutely essential to the creation of this book.

I'd like to start by thanking my awesome wife, Pavlína. Thank you for your valuable feedback, encouragement, and never-ending support on the way. You have always been there for me and your support means the world to me. Thank you.

To Marty McDonough: Thank you for being a caring friend and partner who—despite being a busy CEO—always finds time to discuss important things with me.

I am very grateful to Graham Shaw for sharing his wisdom and experiences with writing and publishing his own books. Thank you.

Thanks to everyone at The Quarto Group who made this experience really nice and smooth. Special thanks to Meredith Quinn, the project editor, for asking for and listening to my suggestions; Joy Aquilino, the editor who guided me through the whole journey; Lydia Anderson, the marketing manager with an open mind and great ideas; and Heather Godin, the art director, for her continuous support and encouragement.

ABOUT THE AUTHOR

David Drazil is an architect who loves to sketch. Every day he shares his passion for the visual representation of architecture through drawings and tips on his website SketchLikeAnArchitect.com and on his popular Instagram account @david_drazil. Through creating educational resources on architectural sketching, David is focused on helping other architects, designers, and hobby sketchers to use sketching as a tool to improve their design process and presentation. A trained architect with international experience, David holds a BSc in Architecture and Building Engineering from Czech Technical University in Prague and an MSc in Architecture and Design from Aalborg University in Aalborg. He also collaborates as a featured artist with the iPad sketching apps Morpholio and ShadowDraw. He lives in Prague, Czech Republic.

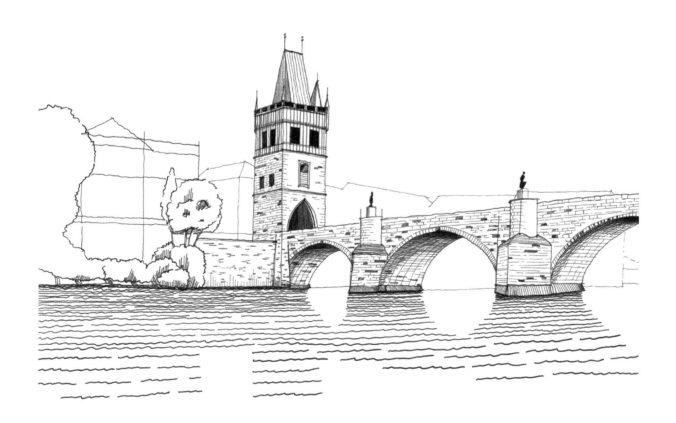

OTHER TITLES IN THE
DRAW LIKE AN ARTIST SERIES

Draw Like an Artist: 100 Faces and Figures
978-1-63159-710-7

Draw Like an Artist: 100 Flowers and Plants
978-1-63159-755-8

Draw Like an Artist: 100 Realistic Animals
978-1-63159-819-7

Draw Like an Artist: 100 Fantasy Creatures and Characters
978-1-63159-964-4

Draw Like an Artist: 100 Birds, Butterflies, and Other Insects
978-1-63159-947-7